ARTS & CRAFTS ERA CONCRETE PROJECTS

ARTS & CRAFTS ERA
CONCRETE PROJECTS

PEDRO·J·LEMOS
RETA·A·LEMOS

4880 Lower Valley Road, Atglen, Pennsylvania 19310

Schiffer Books are available at special discounts for bulk purchases for sales promotions or premiums. Special editions, including personalized covers, corporate imprints, and excerpts can be created in large quantities for special needs. For more information contact the publisher:

Published by Schiffer Publishing Ltd.
4880 Lower Valley Road
Atglen, PA 19310
Phone: (610) 593-1777; Fax: (610) 593-2002
E-mail: Info@schifferbooks.com

For the largest selection of fine reference books on this and related subjects, please visit our web site at **www.schifferbooks.com**
We are always looking for people to write books on new and related subjects. If you have an idea for a book please contact us at the above address.

This book may be purchased from the publisher.
Include $3.95 for shipping.
Please try your bookstore first.
You may write for a free catalog.

In Europe, Schiffer books are distributed by
Bushwood Books
6 Marksbury Ave., Kew Gardens
Surrey TW9 4JF England
Phone: 44 (0) 20 8392-8585; Fax: 44 (0) 20 8392-9876
E-mail: info@bushwoodbooks.co.uk
Website: www.bushwoodbooks.co.uk
Free postage in the U.K., Europe; air mail at cost.

ISBN: 978-0-7643-2833-6
Printed in China

Preface

With eyes opened to the medium, one realizes that our world, like much of the ancients', is constructed of concrete. Concrete is a wonderful medium for streets as well as walls, is readily available, and inexpensive, proving itself time and again in its ability to improve the comfort and convenience of mankind.

What's easily overlooked is the many ways in which it has been applied to the decorative arts of our daily lives, and how it still continues to fascinate artisans. While less-obtainable mediums like marble, clay, metals, and pigments seem to dominate the limelight in the arts scene, select artists have found ways in which the ever-flexible medium of concrete can substitute for all those. While we may have thought we were admiring a porcelain vase or a marble tile, we may in fact have been enjoying concrete's amazing ability to morph into as many forms as an artists' imagination can conjure.

This highly coveted volume finds new life here, reprinted from its 1922 version at a moment in history when concrete is coming to the forefront. New additives, pigments, and ready-made stamps and molds help draw attention to its potential, and slight variations on the age-old formula that make it seem miraculous. It always has been.

Pedro J. Lemos, a notable painter and arts educator, spent years playing with the medium, helping to develop ideas simple enough to be used as classroom projects, complex enough to adorn the fanciest of homes. Using materials and tools readily and cheaply available, he presented formulas for pigmenting concrete and ideas for crafting wonderful objects. Today Arts & Crafts era collectors would treasure the objects he created, though they might not know the maker. With this book, his wonderful ideas can be recreated, perfect for furnishing the bungalows that were designed to showcase craftsmanship style in the 1920s.

This book was cutting edge when it was released; it is no less so today. The mosaic tiles, garden pottery, and molded vases, bowls, and bookends are wonderful projects, easily undertaken in a basement or garage. The recipes for creating faux chimney stones and flagstones are as desirable today as they were when this book was written, and the design tips as appealing as ever.

TABLE OF CONTENTS

LIST OF ILLUSTRATIONS

LIST OF ILLUSTRATIONS

IT IS EVIDENT to the most casual observer that the use of cement and concrete has developed into a most important building material—undoubtedly the most important of the age. Industrial and vocational educators have recognized this importance and thousands of school children have received instruction in its use and application to objects of utility. Its use has been the subject of many books, and the reason for the issuing of this book is to present in printed form the use of color cement for the decoration or surface enrichment of cement and concrete objects. We heretofore have thought of cement in terms of rough surfaces and crude retaining walls, little thinking that beautiful patterns and textures are possible with proper combinations of color with cement, presenting possibilities for producing art tiles, pottery, and decorations of a high art quality.

After a study some years ago of the various forms of producing clay pottery and its possible relation to school arts and industrial education, the handicap of necessary firing to give permanency loomed large against its general adaptation by schools. This resulted in considerable research and experimenting by the authors with cement and the use of color in the endeavor to parallel in some measure each of the methods employed in the making of fired tiles and pottery. Particular attention was given to simplifying the process of securing permanent form to many of the plastic forms of schoolroom art, which have been presented in clay and other perishable mediums. With the projects presented in the following chapters permanent useful objects can be secured by students in their school art subjects. Attention was also given to the enriching or refining

by decoration the many objects heretofore made in cement and concrete by vocational classes. The problems and methods explained in the following description solve this need.

Craftsmen or amateur home-workers who delight in creating and building objects of beauty around them can find in color cement a medium which will appeal to their needs, in that the necessary working equipment is simple and the work can be done within small space.

The following chapters by no means complete the story of color cement. They record the results of the work of the authors and it is hoped that it will stimulate interested readers to carry this delightful handicraft to even greater achievements.

The results achieved have been accomplished through several years' patient experimenting by the authors, but the realization that many other teachers, craftsmen and students will be aided in continuing this delightful, durable handicraft, is in itself an enjoyable reward to the authors for their efforts.

<div style="text-align: right">

Reta A. Lemos
Pedro J. Lemos

</div>

CHAPTER 1
Materials and Equipment

IN THE MAKING OF COLOR CEMENT HANDICRAFT the chief material used is Portland cement. While this material has assumed a most important part in the building history of our present time, there are not many who know its history and source, and as every craftsman is a better craftsman if he knows something of the story of the material with which he works, here is the brief story of Portland cement.

PORTLAND CEMENT DERIVES ITS NAME because of resemblance in color to a stone quarried near Portland, England, and it was named by its inventor, Joseph Aspdin in 1824. It is a manufactured product produced by a scientific process. At the beginning of the Christian era the Romans used a natural cement very extensively, and many fragments of color frescoes and friezes remain from the work of the ancients, showing that they used color with their work.

THE PRINCIPAL INGREDIENTS OF PORTLAND CEMENT are lime, silica, iron, and alumina. These materials are mixed in definite proportions and then subjected to a degree of heat that almost causes them to melt, forming a clinker or slag. This clinker is ground until it is reduced to a powder, and this is the Portland cement. Portland cement is generally mixed with an aggregate to produce strength and this aggregate is usually stone, gravel or sand. The third material needed to complete the combination is water.

SUCCESS IN THE USE OF CEMENT depends largely upon cement that is fresh. Cement is very sensitive to moisture and if kept where fogs, dew or moisture of any nature is absorbed into it, the first set or "hydration" takes place and destroys its use for fine handicraft.

TO TEST FRESH CEMENT when the cement sack is open, thrust the hand into it and see that no hard lumps are in it. Fresh

cement will feel slippery and soapy when rubbed between the finger tips. If it feels gritty and sandy it may do for the rough parts or body of vases and tiles, but only fresh cement should be used to mix with color and for surfacing purposes.

THE PROPER CARE OF CEMENT requires that it be kept in a covered receptacle and kept in a dry place, preferably up from the floor if the floor is near the ground. It should be kept in a dry, tight work-shop and the doors should be kept closed at night to avoid any moisture from the night air reaching it. Nothing can restore spoiled cement and it should not be used as the results will be discouraging.

GOOD GRADES OF AGGREGATES SHOULD BE USED in cement work. Clean sand should be used and a sand that is not too fine is preferable. Gravel and crushed rock used in large work such as garden seats, large bowls and outdoor problems should be of a good grade to form a good mixture.

THE WATER USED IN CEMENT WORK should be free from all impurities. Moderately warmed water will hasten the setting or hardening of cement while very cold water retards the hardening.

THERE ARE TWO COLORS OF CEMENT, gray and white. Portland cement is gray in color and a white cement is also made that is a refined form of cement. White cement is not as hard or durable as gray cement, but gives a smooth surface and sets as satisfactorily as the gray cement. It is more expensive than the gray cement and should not be used later than six months after the sack is opened.

WHEN CEMENT IS USED ALONE IT IS TERMED "NEAT." When it is mixed with rock, gravel or sand it is termed "concrete." Concrete produces strength and the neat cement produces a smooth texture and surface. When concrete is used the cement and water will rise to the top and if the surface is worked

and pressed with a trowel the cement is "flowed" to the top, producing a smooth surface.

MOLDS ARE USED FOR FORMING CEMENT AND CONCRETE, and are made from wood, metal or plaster-of-Paris. The forms in all instances should be tied or braced together to prevent the moisture of the mixture from running out, as the water is essential to the successful hardening of the cement. In the making of cement pottery and tiles, plaster-of-Paris molds or forms are generally used and plaster-of-Paris therefore forms an important material in the making of color cement handicraft.

Plaster-of-Paris is made in different degrees of setting periods. These are quick-setting, medium-setting, and slow-setting. Casting plaster or sculptor's plaster should be asked for and a medium- or slow-setting plaster is preferable for the beginner.

CEMENT, AGGREGATES, WATER AND PLASTER FORM THE MAIN PARTS of our working materials excepting the color, which is especially described in the chapter on Color.

THE EQUIPMENT for concrete pottery is simple, and much of it may be pressed into service from material to be found about the house or workshop. Inventive ingenuity on the part of the worker will find clever uses for many discarded kitchen utensils and unused tools.

Following is a list of convenient things needed to produce pottery. These may be added to or elaborated through personal requirements.

WORKING EQUIPMENT.
galvanized iron pans about 2 x 3 feet
2 large spoons
4 or 5 pans
2 ladles
1 large file or rasp

2 table knives
3 pieces of ordinary glass about 12 x 18 inches
1 palette knife
1 lb. modeling wax
1 bristle brush ½ inch wide
2 small sable oil brushes, No. 1 or 2
1 small clay-modeling tool
2 pieces of thin wood for mixing paddles
½ doz. small saucers or butter dishes
strips of thin metal
thin soft wire
1 sifter
2 pails
muller and pestle
several pieces of surfaced wood about 12 inches square.

With a flat table to work on, running water or a pail of water handy, a box to receive waste plaster-of-Paris and cement, the proper environment for color cement is set.

GALVANIZED IRON WATER TRAYS can be made by taking a three-inch by seven-inch sheet and cutting a two-inch strip off of one end, reserve for making scrapers and other useful tools. Cut the remaining metal into three rectangular sections for trays.

To make the trays, lay one of these pieces over a strong box with an even edge and hammer into tray shape as shown in the accompanying plate. The corners should be bent so as to make the trays waterproof without soldering. A wooden mallet should be used for hammering the metal as a metal hammer may cut the metal.

MOLDING CASE. Several pieces of board hinged together with one series of edges coming so that they will rest evenly on a flat surface, will produce an adjustable case to use in making molds. A strong cord will keep it in place. A strip of metal (tin, brass or iron)

may be used as a cylinder, the circumference being pressed in and tied to conform to the dimensions of the object to be molded.

MIXING PADDLES. Paddles for mixing plaster or cement can be made out of firm wood strips and handles shaped to fit the hand.

INCISING TOOLS. A nail hammered into a piece of firm wood and the head snipped off with nippers then sharpened with a file or emery stone until it is a tapering wedge point. Nut picks may be filed down slightly for this purpose. Two or three points of varying widths will be handy to have, particularly when some of them disappear occasionally as all small tools will.

SCRAPER. A piece of barrel stave or heavy wire bent like a croquet wicket with a wire fastened from end to end is particularly convenient where a number of clay or plasticene tiles are to be produced. For class use two strips of wood are fastened to the bench, the desired width separating the strips. Between these strips a piece of strong paper should be laid and the clay or plasticene pressed firmly onto it between the strips. The scraper will shave the surplus clay if it is moved along so that the wire rests on the wooden strips. Measure off the six-inch or eight-inch squares, cut across with a knife from strip to strip and remove the squares by sliding the paper out. This will give a smooth, even surface on which to model or incise designs.

THE OTHER ITEMS OF EQUIPMENT all have their part to play as follows:

2 large spoons—For handling plaster and cement.
1 large file or rasp—For occasional use on the tile edge.
3 pieces of glass—On which to cast tiles.
2 table knives—For paring molds, etc.
1 palette knife—For working color into cement.

1 bristle brush—With which to oil molds.

Small modeling tool—To use on clay and plasticene.

Nut picks—For incising.

½ doz. small saucers—In which to mix colors.

Thin soft wire—For cutting molds.

Sifter—To sift cement and color for glazes.

2 pails—In which to mix cement and plaster.

Muller and pestle—Grinding mineral colors with cement.

It may be unnecessary to add that the old axiom "A place for everything and everything in its place," will do wonders toward keeping the temper sweet, and a good temper is a most necessary ingredient for producing good cement handicraft.

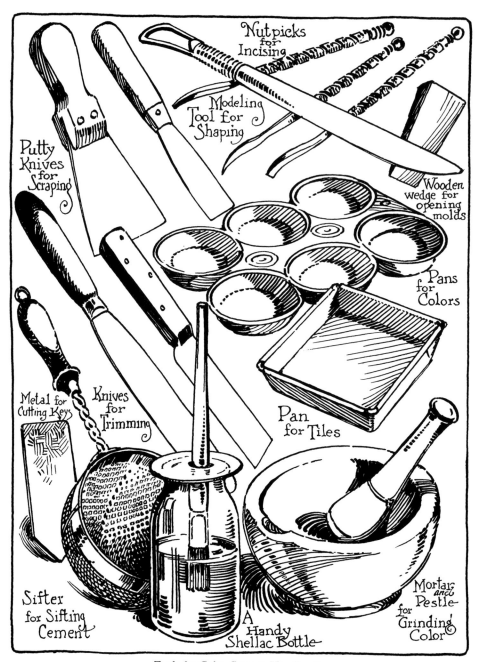

Nutpicks for Incising

Modeling Tool for Shaping

Putty Knives for Scraping

Wooden wedge for opening molds

Pans for Colors

Metal for Cutting Keys

Knives for Trimming

Pan for Tiles

Sifter for Sifting Cement

A Handy Shellac Bottle

Mortar and Pestle for Grinding Color

Tools for Color Cement Handicraft

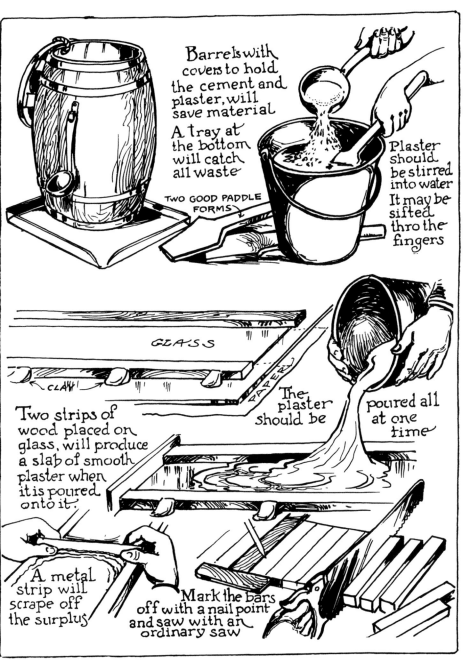

The Mixing of Plaster-of-Paris

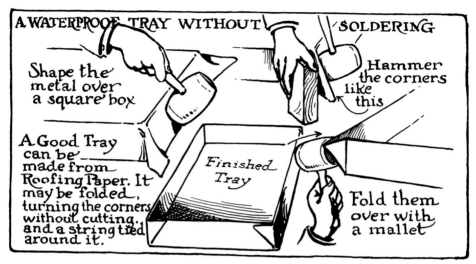

A WATERPROOF TRAY WITHOUT SOLDERING

Shape the metal over a square box

Hammer the corners like this

A Good Tray can be made from Roofing Paper. It may be folded, turning the corners without cutting, and a string tied around it.

Finished Tray

Fold them over with a mallet

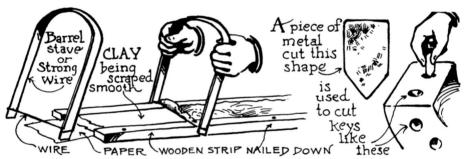

Barrel stave or Strong Wire

CLAY being scraped smooth

A piece of metal cut this shape is used to cut keys like these

WIRE — PAPER — WOODEN STRIP NAILED DOWN

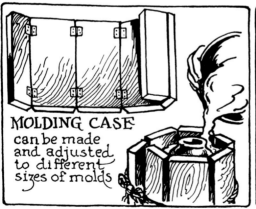

MOLDING CASE can be made and adjusted to different sizes of molds

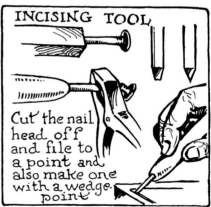

INCISING TOOL

Cut the nail head off and file to a point and also make one with a wedge point

Helpful Material for Color Cement Handicraft

CHAPTER 2
The Making of
Plaster Molds

THE SUCCESSFUL USE OF PLASTER is such an important part in the making of color cement tiles and pottery that as a preliminary step or auxiliary to the cement craft it should be well accomplished by the student before using the cement. It is not at all difficult and for those who have not used plaster, there awaits an interesting medium for all forms of plastic applications or adaptations. Our concern with it will be in the making of successful molds for the producing or reproducing of our cement tiles and pottery, but a whole book could be written upon the making of plaster objects. The uses of plaster form a large industry and many art objects are produced in plaster for many forms of applied art.

PLASTER IS SENSITIVE to moisture, and should be kept in a dry place. If plaster does not set within a short time it probably is old and even if it does set in time it will have a tendency to pulverize. It is always safer to purchase an entire sack than to purchase a small lot from the hardware dealer, grocer, or druggist, for the chances are that his plaster has been exposed in a bin so long that its strength has vanished. This is mentioned because instances have been known where trouble in cast making was traced to just such conditions.

ON RECEIVING THE SACKS OF PLASTER AND CEMENT the tendency will be to let contents remain in the sacks. It will be found much more convenient and economical to empty the sacks into a small barrel or box to which a cover has been made. A tin tray under the box or barrel will catch all waste that may drop around the edge, preventing the material from being tracked over the floor. A nail or hook on the side of the barrel for holding the ladle or spoon used for taking out the plaster will enable you to find it when you need it.

THERE ARE VARIOUS GRADES OF PLASTER, but the best for this purpose is molding plaster. The plaster should always be kept in a good dry location.

TO MIX PLASTER SUCCESSFULLY for molds observe the following directions: A bucket or pan large enough to contain the required amount of plaster needed should be used. Then half the water for the amount of plaster used should be poured into the bucket. Sift the plaster-of-Paris through the fingers into the water, until the water absorbs it no longer. This can be determined by small portions of the plaster remaining on the surface. Then stir the whole mass slowly with the mixing paddle until the passage of the paddle through the plaster leaves a channel which closes up slowly.

IT IS THEN POURED PROMPTLY into the center of the space on the glass prepared for the plaster tile so that the poured plaster gradually spreads from the center toward the corners and edges filling up the spaces and coming up the sides to about one-half inch height. Jarring the table or a slight shaking of the glass will cause the plaster to settle very level as well as causing any bubbles in the plaster to rise to the surface and break. Care should be taken that the plaster is not too thick before being poured. This stage of the proceedings requires one having their wits alert, and discussing Futurist art or any other topic may result in "try, try again." If the plaster appears too thin more plaster should be added until it is the proper consistency.

After the plaster is poured it should set for about half an hour (varying according to the dryness of the atmosphere) before any attempt is made to remove it. Meanwhile all buckets, paddles, ladles, etc., containing plaster should be cleaned while the plaster is soft and easy to remove.

WHEN THE PLASTER MOLD IS READY TO REMOVE, a table knife slightly inserted between partitions and carefully pryed will cause the parts to separate. A most important part of casting molds and the using of the plaster molds is the oiling. All parts of the molds to come in contact with fresh plaster, cement or concrete must

be thoroughly oiled or greased to prevent them sticking to each other. If wood, glass or metal is used with plaster, cement or concrete, remember to oil or grease such surface before pouring the plaster or cement on it. If you do not, you will have to use a chisel and with discouraging results.

The best way to oil the surface is as follows:

GLASS—Apply salad oil with brush or cloth removing as much as will come with the palm of the hand.

PLASTER BARS AND MOLD should first be soaked in water ten or fifteen minutes to prevent drawing the moisture out of the fresh plaster or cement. Wipe off surface moisture with soft cloth, and replace with oil, before using for molding. If oil is left thick or in brush streaks, it will leave its influence on the surface of the casting.

WOOD—A smooth-surfaced wood should always be used, and oiled well.

A good grease formula for all surfaces is as follows: Three parts paraffin and one part tallow, melt and add one pint of kerosene. This is applied with a brush.

AS AN EXPERIMENT PROBLEM for the use of plaster so as to become familiar with its use, we will proceed with the casting of a simple flat plaster tile.

Taking a piece of glass, smooth board, marble or oil cloth, brush the surface with a little salad or lubricating oil, or linseed oil. There should be no free oil on the surface or streaks of oil as such will cause an uneven surface. When using glass it is possible to insert a diagram or pattern of the shape underneath on a piece of paper as a guide to the bars or retaining walls of the mold. These retaining bars or walls may be of various materials. Strips of wood or plaster are excellent and strips of linoleum, metal and even glass are used. If four pieces of wood about ten or twelve inches long and one and one-half inches

wide are used they can always be adjusted to fit any dimension from twelve inches down, by being placed as shown in the diagram.

TO OIL THE RETAINING BARS, brush the surface to come in contact with the plaster and then hold the wood in position over the diagram below, using modeling wax or clay to keep it in position. The clay of course should always be in position on the outside of the wood and should never be in the space into which the plaster is to be poured.

PLASTER HARDENS SLOWLY IN COLD WEATHER and hardens rapidly in a warm temperature. Salt added to plaster will cause it to set more rapidly and to harden more firmly. No exact proportion can be given—just a little sprinkled in a pan of plaster will cause it to set more rapidly.

DIFFERENT PLASTERS SET AT DIFFERENT PERIODS. As has been described before, casting plasters can be secured in quick-setting, medium- or slow-setting mixtures. Medium-setting or slow-setting will be found to be good average mixtures for use.

TO RELEASE THE PLASTER TILE after it has hardened (generally a half hour will insure the hardening action as being completed), the bars can be released and the tile gently lifted at one corner will cause it to come apart from the oiled surface. If glass is used the glass can be placed upright and the separating of the tile from the glass can be watched as indicated by the moisture suction disappearing as the tile is gradually separated. If oilcloth is used the tile can be turned over and the oilcloth peeled off easily. This of course is necessary only where any sticking occurs, for most times the tile will separate easily. If sticking does occur it is generally some fault of the oiling for it needs only one or two little spots overlooked to cause considerable trouble as the plaster will stick to any part that has been skipped in the oiling.

Plaster dries rapidly and will dry in the sun more rapidly. When plaster is damp it can be scraped or carved easily. Temperature and the age of the plaster affect its drying periods.

LARGE TILE MOLDS should be strengthened by having burlap strips or wire imbedded into the back while the plaster is soft. This creates a stronger layer than where plaster alone is used. Wood strips should not be used for backing plaster unless thoroughly dried as otherwise it causes cracking by its shrinkage, and it is best not to use it for reinforcing.

TO CORRECT FAULTS IN PLASTER CASTS use a little of the plaster scraped from the back to fill in holes or defects. If a corner or portion is broken off, gouge a hole or cavity so that a little plaster mixed and placed on that section will become firmly connected. As it hardens, a little of it can then be scraped with a knife to connect correctly with the surrounding parts or surface.

A SECOND PRACTICE PROBLEM is to take the plaster tile and incise a line pattern in the surface. To make the incising easier, dip the tile in water and then trace the design previously prepared onto the plaster. Pressure alone on the paper with a pencil will make an indentation on the plaster that can be easily followed in the incising.

THE DESIGNS FOR INCISED PATTERNS are best where the lines enclose a shape. The parts are more comprehensive and confusion of the lines will not result if simple outlines are used. In the chapter on Design, line patterns are shown that are adaptable to incised work.

TO INCISE THE PATTERN take a nail point or nut pick or other metal point and shape the point on a grindstone or by the use of a file so that each incised line will have a tapering side. If any undercuts are produced the cast or plaster that is poured into it will become locked and refuse to separate.

The tile is next immersed in water, taken out and after the water is absorbed, a brushing of oil is given to it.

A PLASTER TILE IS MADE MORE DURABLE if it is dried and given a coat or two of shellac before it is used for molding plaster or cement. Otherwise repeated brushing of damp plaster with the oil brush will gradually wear the edges and details of the mold away.

TO MAKE A CAST FROM THE PLASTER MOLD, it is surrounded with the retaining bars after they have been oiled and held in position with the modeling wax or clay; this time they are placed firmly against the sides of the plaster mold.

THE CAST OF OUR FIRST EXPERIMENT now becomes the mold for our second practice problem as the mold is always the part that produces the cast. The cast in turn may become a mold for another cast.

TO SEPARATE THE CAST FROM THE MOLD the bars are removed and a knife edge is pressed between the parts to separate them. Care should be taken not to become too anxious and force the sections apart before the cast has dried or they will cause it to break. If it refuses to come apart easily when completely dry, a little wooden wedge tapped into the crevices in one or two places will cause it to part easily. Sometimes plaster flows over the sides of the mold and binds the edges together. On removing the mold and cast from the retaining bars, examine it to see if any plaster is binding it and if so remove it.

IF THE PARTS ARE ABSOLUTELY SOLID it is because the incising was not properly done and the lines interlock somewhere and the only thing to do is to break them apart and correct the faults and try again. Sometimes when interlocking tiles are separated the faulty parts have fragments of the opposite part attached in the defective parts showing where the faults are located.

THE TWO PLASTER TILES SHOULD BE RETAINED for they can be used in casting plain cement and color cement tiles in various finishes. When they have completely dried they should be given two or three coats of thin shellac, a day apart, on the surface only, which will make them good durable molds for future use.

CASTING IN THE ROUND is more difficult than flat casting or bas-relief work and while the making of plaster molds for vases and bowls is given particular attention in the chapter on Cement Bowls and Vases, directions for casting objects in the round will be given here.

AS A GOOD TEST PROBLEM take any small object or toy and, if it is wood, oil it well. If it is porcelain or glass it will not need to be oiled. A simple form, animal or bird, can be made in modeling wax or clay to be used as the original or model from which to make a mold. The best objects are those modeled in broad surfaces with but little detail.

PREPARING FOR CASTING. The equator or half-way mark should be marked on the surface of the object, as one-half of the mold should be made at a time. Instead of one-half, one-third is often used on round objects to permit easier release of the molds. Mold divisions when possible should follow corners of objects.

THE FIRST SECTION of the mold is made by placing a layer of clay along the division lines on the object which have been indicated as division lines for the sections of molds. Sometimes the object can be laid on the table or on glass and the plaster poured around it up to the half-way line as shown in the accompanying plate. In this method a strip of linoleum or metal can be placed around it to make a retaining wall for the plaster.

AFTER THE FIRST SECTION is cast, the model is removed from the plaster and if the plaster has risen past the equator it should be scraped back and indentations or "keys" made in the plaster

portions that are not those producing the parts of the model. The model is replaced in its hollow and the entire surface of the mold that is exposed is oiled, including the sides of the metal, linoleum or whatever is used as retaining walls. Plaster is again poured for the second half after which it is permitted to dry before separating the mold sections.

OILING. It must be remembered that the molds must be oiled after each casting as each pouring absorbs the oil. All surfaces coming in contact with the next pouring of plaster must be oiled to cause separation.

POURING. A hole must be cut in the molds to permit the plaster to enter. Air holes leading upward as shown in the engraving are scraped upward out of the molds to permit the escape of the air; otherwise air bubbles may be formed in the plaster causing defects.

TO HOLD MOLD PARTS TOGETHER tie a cord or wire around parts. Notches cut on corners or edges of molds to hold the tieing cord will prevent them from slipping. Molds should fit closely together. If for any reason they do not, the crevices can be filled with modeling wax as a temporary filler. The best results are obtained, however, from perfect molds and it is a saving of time to make a mold over if it is not perfect in the first casting.

RELEASING CAST. After the plaster has set long enough to harden, the molds are opened by gentle prying or tapping with a wooden wedge. Often an obstinate cast is released by placing the mold over a stove or flame for a few seconds. This causes the steam formed in the mold to separate the mold from the cast.

CEMENT BOWLS AND VASES are made by pouring thin cement into the molds and rotating the mold and pouring out the surplus cement. After a few minutes another layer is poured in and the operation repeated. This method is explained more fully in the chapter on Bowls and Vases.

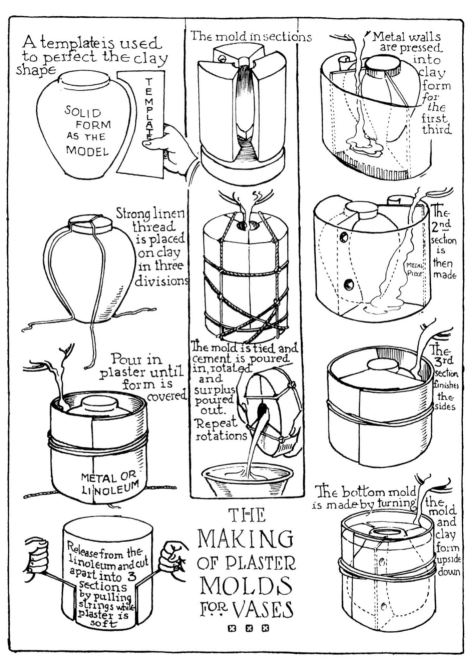

A template is used to perfect the clay shape

SOLID FORM AS THE MODEL

TEMPLATE

The mold in sections

Metal walls are pressed into clay form for the first third

Strong linen thread is placed on clay in three divisions

The 2nd section is then made

METAL PIECE

Pour in plaster until form is covered

METAL OR LINOLEUM

The mold is tied and cement is poured in, rotated and surplus poured out. Repeat rotations

The 3rd section finishes the sides

Release from the linoleum and cut apart into 3 sections by pulling strings while plaster is soft

THE MAKING OF PLASTER MOLDS FOR VASES

The bottom mold is made by turning the mold and clay form upside down

The Making of Plaster Molds

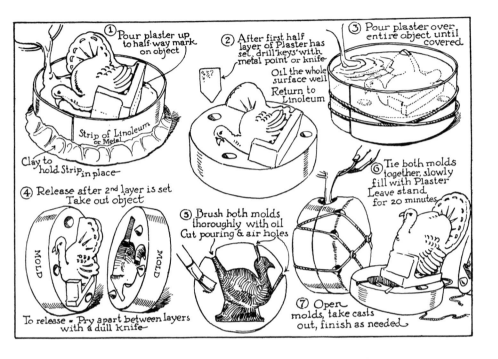

① Pour plaster up to half-way mark on object

Clay to hold Strip in place

Strip of Linoleum or Metal

② After first half layer of Plaster has set, drill 'keys' with metal point or knife

Oil the whole surface well

Return to Linoleum

③ Pour plaster over entire object until covered

④ Release after 2nd layer is set Take out object

MOLD MOLD

To release – Pry apart between layers with a dull knife

⑤ Brush both molds thoroughly with oil Cut pouring & air holes

⑥ Tie both molds together, slowly fill with Plaster Leave stand for 20 minutes

⑦ Open molds, take casts out, finish as needed

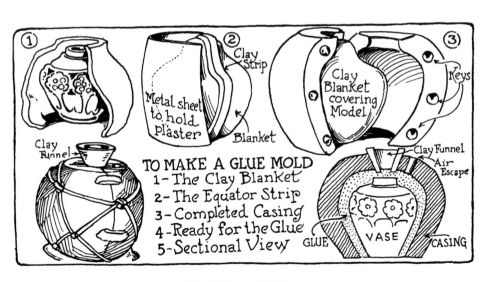

①

② Clay Strip

Metal sheet to hold plaster

Blanket

③

Clay Blanket covering Model

Keys

Clay Funnel

Clay Funnel

Air Escape

TO MAKE A GLUE MOLD
1 – The Clay Blanket
2 – The Equator Strip
3 – Completed Casing
4 – Ready for the Glue
5 – Sectional View

GLUE

VASE

CASING

The Making of Molds

CHAPTER 3
Plain and Incised
Cement Tiles

A KNOWLEDGE IN MIXING CEMENT is the next step necessary in Color Cement Handicraft. The steps necessary toward mixing cement are simple, the main point being that the cement should be fresh. The student is cautioned to test the freshness of cement by seeing that no caked or hard lumps of cement are contained in the sack mixture. As formerly explained the cement should have a smooth, slippery feeling when passed between the fingers.

NEAT CEMENT is the term applied to cement mixed with water without the addition of any sand or gravel. Neat cement produces a very smooth surface and responds to reproducing every change in the surface of the model. It should be used on the surface only and not for the entire tile or pottery. If used without any sand or gravel, it is termed "too fat," and has the fault of cracking sooner or later. Therefore neat cement is always backed up with a concrete mixture.

CONCRETE is a mixture of sand and cement, gravel and cement, or rock and cement. In all instances where such a mixture is made, the two parts should be *mixed dry* before any water is added. Only enough should be mixed to meet immediate needs as it is not best to use cement that has stood so long that it has commenced to harden.

TO SECURE A VERY FINE SMOOTH SURFACE for tiles or pottery the cement should be used neat. It must be sifted dry through a fine sieve and enough water added to make it of easy working consistency. Then a mixture of two-thirds gravel or sand and one-third cement with water added may be used on the back of the tile or the inside of a vase and possibly again lined with a mixture of neat cement.

Cement or concrete can stand for an hour or two and again be used by adding more water and mixing thoroughly. This cannot

be done with plaster and should be avoided with cement or concrete. If chemical action has commenced and the cement has partly set, it naturally will have lost much of its strength for second use.

A CONCRETE MIXTURE of one part cement and two parts sand or gravel will give good strength. The sand or gravel must be clean. If it contains any vegetable matter or other sediment, it should be avoided. To test your sand quality put a four-inch layer in an ordinary quart jar, fill with water within three inches of the top. Cover and shake well. Then permit the sand to settle. If the sediment or loam which remains at the top of the sand is one-half inch or more, the sand is not fit for use in concrete.

CEMENT MIXTURES ADAPTABLE TO VARIOUS USES are given below. These may be used for backing and reinforcing large problems, in garden pottery, garden furniture or walls.

1. **RICH MIXTURE**
 1 part cement
 2 parts sand
 5 parts gravel

2. **STANDARD MIXTURE**
 1 part cement
 2 parts sand
 4 parts gravel

3. **MEDIUM MIXTURE**
 1 part cement
 2½ parts sand
 3 parts gravel

4. **LEAN MIXTURE**
 1 part cement
 3 parts sand
 6 parts gravel

Cement and sand mixed dry first, then with water. The gravel is mixed wet with other mixture and thoroughly combined.

Builders use the Rich Mixture for columns and high stresses, and where water tightness is necessary.

Standard Mixture is used for arches, for tanks and sewers, and for machine foundations.

The Medium Mixture is used for piers, sidewalks, and heavy walls.

The Lean Mixture is used for walls, foundations and for unimportant work.

THE FIRST PROBLEMS IN CEMENT should be the casting of cement tiles without the use of color. As a beginning problem set the retaining bars around a six-inch square space and mix a neat mixture of cement and pour into the space so as to make about a quarter-inch layer. After this has set for about fifteen minutes pull some of the neat cement up the sides with a putty knife or strip of cardboard and then pour in the remainder of the tile concrete mixture of one-third cement and two-thirds sand. This will result in a tile with the top and sides surfaced with neat cement. The surfaces of the bars and the glass or other under surface have of course been properly oiled previous to the pouring.

BEFORE PROCEEDING WITH TILE MAKING it may be necessary to make a number of plaster bars to use as retaining walls. These are made as follows: Two strips of wood one-half inch to an inch thick laid parallel on a glass or other smooth surface that has been greased with oil. The distance between the strips of wood should be about ten inches, as the length will then serve for producing eight-inch tiles or any size under this dimension. The edges of the wood facing inward should always be oiled, the wood strips are held in position by small lumps of modeling wax pressed firmly into the outer edge of the wood so that it attaches it to the surface of the glass. This will leave a channel between the two wooden strips into which the plaster is poured. The two ends of the channel may be stopped with blocks of wood or blocked with wax or clay. As soon as the plaster is poured into the mold it should be evened by running a straight strip of wood or metal over it spanning the width of plaster. Run this back and forth to trim off the surplus, so that the plaster will have an even thickness when removed from its bed.

TO REMOVE THE PLASTER first remove the wooden strips and then tap the layer of plaster lightly on the edge with a hammer. This will loosen it. Then with a T square and sharp nail mark off

bars five-eighths inch wide and also bars one and one-quarter inches wide. At least twelve bars of each width should be made. After drying for three days the bars may be sawed apart with any sharp saw, care being taken to hold the saw within the groove made by the nail. The edges of the bars may be further smoothed if necessary with a knife or file.

STRIPS OF WOOD WITH SURFACED SIDES can be used in the place of plaster bars and if oiled will release very easily from the plaster when used as retaining walls.

TO MAKE AN INCISED TILE in plain cement proceed as follows: Roll out clay or modeling wax to about one-half inch thickness and cut to the desired size of tile. Cover this smooth surface, place a design which has been made on thin paper and trace with a pencil. The paper should be held so as not to slip and the result should be a slight indentation of the design on the clay. These lines are then incised over with the incising tool to the desired depth, care being taken that no over-hanging edges remain on the edges of the incisions. The incisions should have sides slightly sloping inward and if the tool is correctly shaped it will produce such lines.

THE DESIGN should be planned to be at least one-half inch from edge and simple in construction. Avoid a tangle of ever crossing lines. A geometrical arrangement dividing the square into pleasing spaces will produce the best results.

Place the tile on a level surface and take four bars of the one and one-fourth inch plaster strips or wood, soak in water for fifteen minutes, wipe dry and oil. Now place the four bars so that the inside edges are against the wax or clay tile and fasten so that they are unmovable with modeling wax. The bars if placed with one end projecting past the bar meeting it at right angles permits their adjustment to any size tile under ten-inch dimensions. Onto this pour plaster-of-Paris, pour into the center letting it run toward the edges forcing

all air ahead of it as it enters the incisions. Level off surface and remove the plaster cast from the mold as soon as it has hardened.

TO RELEASE THE PLASTER CAST first remove the surrounding bars and lift the plaster tile off the clay. The plaster tile will have the design in relief on the surface. If any clay is adhering to these relief lines, it is evidence that there are overhanging edges and such edges should be trimmed with a knife before the next step. The next step is as follows: After plaster tile is dry put it in water for a few minutes, then oil the surface well. Place back in the bars and repeat previous operations excepting that this time a cement mixture is used instead of plaster. A mixture of neat cement should be used half way up and permitted to remain for five minutes before the concrete (one-third concrete, two-thirds sand) is poured in for the remaining half.

IN MIXING SAND AND CEMENT it should be remembered that they should be mixed together thoroughly *while dry* before any water is added. After the cement has been poured into the form, if it is to be used for floor or wall purposes, four small squares of cardboard should be pressed into the exposed cement which is the back of the tile. This should be done about fifteen minutes after the cement has been poured, when it is not too soft.

The tile may be removed after it has remained in the form for twenty-four hours. A thin cement mixture of another color may be made and brushed over the tile and the surplus removed, leaving the last color only in the incisions.

AN INTERESTING VARIATION is produced by cutting away the clay or wax between the incisions of the pattern to the depth of one-half inch or less, making a mold of this tile and in turn casting a concrete tile. The result will be a surface with relief section and low spaces, the relief being concrete and rough in texture.

These low spaces are then filled with a colored cement of another color, or neat cement, and brought to the level of the relief surface. Such a tile secures a pattern adaptable to tile walks, or any surface which is subjected to wear, in that the design is not only a thin surface layer, but a thick portion of color that will not disappear with the wearing of the surface layer.

A SIMPLE METHOD OF MAKING TILE MOLDS is to cut a design from a thick piece of cardboard or sections of a design, and glue these in proper position to carry out a design arrangement. These pieces should be cut with tapering sides so as to permit of proper "draught" or releasing conditions when the plaster cast is made for mold purposes.

The pieces of cardboard should remain glued until dried to avoid the moisture of the soft plaster moving the parts around.

WITHOUT THE USE OF COLOR a number of pleasing and varying textures can be secured with plain cement, as the gray color of the cement has an artistic quality, and it is well to become well grounded in the use of cement before combining color with it.

SEVERAL WAYS OF USING PLAIN CEMENT FOR TILES beside those already given are explained in the following descriptions. These are termed Traced Cement, Burnished Cement, Scraped Cement, Concrete Tile, Cement and Concrete Tile, Glazed and Dull Cement Tile, Glazed Relief Line Tile.

THE TRACED CEMENT TILE is made by pouring a half-inch mixture of concrete (one-third cement, two-thirds sand) into a mold made with the usual retaining bars of any desired dimensions. Over this concrete mixture a layer of about one-quarter of an inch of sifted neat cement mixed with water should be placed. At a certain degree of hardness this layer of neat cement will yield to a slight indentation or traced outline. This condition can be tested by touching the edge of the surface with a pencil point to see whether it is too

hard or too soft. A good plan is to pour the mixture in the evening and it is generally in right consistency to work upon on the following morning. The surface should be nearly hard but still sensitive to pressure with a point.

HAVING PREPARED THE DESIGN on a piece of paper about the weight of business writing paper, the design is placed on the surface of the tile and kept in the same location while a blunt, soft lead pencil is traced over the pattern, pressing firmly to create a good indented line in the cement surface. The design for this work is best where the pattern is easily expressed in lines or outlined forms. The forms can be increased in strength by rubbing the pencil on the outer edge of the lines to be slightly modeled in separate appearance. When the design has been completely gone over, the tile is placed in water for several days, after which it is dried and a thin coating of color wash (see chapter on Surface Finishes) may be added to it which will further the pattern by coloring the traced lines.

THE BURNISHED CEMENT TILE is produced by casting a similar tile to the one made for the Traced Cement Tile and proceeding in the same manner, excepting that the spaces between the forms are burnished smooth with the dull pointed pencil or a smooth small stick. This results in some parts being burnished or pressed down while others remain in slight relief. A change in this is also produced by scraping the smooth surface off between the lines in certain places instead of burnishing it. This results in parts of the surface being of a different texture and also of a little different color, as the scraped parts are different in both these respects to the cement which has dried and remains untouched on the surface.

A SECOND BURNISHED TILE EFFECT is to pour a layer of neat cement first in the mold and a concrete mixture last. When this is hard enough to remove, and still soft enough to work upon (the neat cement layer having been in the bottom will dry with a dull

finish and not a glaze finish as when flowed on as a top layer) it should be removed and the design traced upon this neat cement surface. If a leather tool or smooth hard point is used, certain parts as desired can be worked upon, smoothed down or pressed in, through the paper which will create a change of surface texture.

THE SCRAPED CEMENT TILE is where either the top neat cement or bottom cement layer has the design in line or form scraped out of the cement, the entire design being produced without a plaster mold being used. A sharpened nail or nut pick will make a good scraper and this scraping and pressing is done on the cement surface direct and not through a paper as in the two previous problems. This direct method of working upon cement surface is considered more thoroughly and more extensive applications made of it in the chapter on Carved and Modeled Cement.

THE CONCRETE TILE. Varying finishes may be secured in casting any cement tile by the kind of aggregate used with the cement. A rough irregular small crushed rock will give one kind of texture, while a round small white gravel will give another and each change will present different effects. Without going into extremes of finishes or having too many changes in the surface of a tile, pleasing effects can be secured by one to three changes of texture secured by putting different mixtures in different parts. This may be done by mixing and applying with a brush or spoon the different mixtures into the mold, placing the mixtures each in their proper section of the mold. The whole is then covered with the backing mixture resulting in the surface pattern appearing with the changes after the tile has been released from the mold.

Where a concrete mixture is to appear rough in texture, the sand or gravel and cement should be mixed dry, just enough water added to cause it to mix up to a damp consistency so that it can be shaped with the hand. This can then be put in the mold and tamped slightly

with a block of wood to press it in true contact with the surface of the mold. This will result in a porous, open texture, producing good contrast with neat cement parts that have been previously placed or are to be added.

THE CEMENT AND CONCRETE TILE is made with plain cement producing added interest to the design by the two textures or surface finishes that occur between cement and concrete. The design for such a tile is best where the parts are separated either by an incision or a relief line. The plaster mold should therefore present separate portions, some of which can be considered for the cement parts and others for the concrete parts.

By mixing neat cement until it is of a thin mixture, the mixture can be placed on the mold wherever wanted by dripping it from a brush. Care should be taken in the use of a brush with cement that a wiping stroke is not used as such a stroke will remove the oil from the plaster surface and cause parts of the cement to stick to the plaster.

After the cement has been placed, a concrete mixture is made and poured into the space up to the desired height to produce the necessary thickness. This will at the same time fill in the remaining surface spaces of the tile.

THE GLAZED AND DULL CEMENT TILE is produced by filling in with clay or glued cardboard bits cut to shape, those parts that are to be glazed gray cement. Do not use modeling waxes or artificial clays for this part as the oil or grease in them will interfere with the glazed cement adhering to the surface in the final finishing.

After the cardboard or clay is dry a layer of neat cement is poured in, and backed with the usual concrete mixture. After the tile is released, the cardboard bits or clay is removed and cleaned out, the surface under it is roughened with scratched lines and the tile is put in water for an hour. The spaces are then filled with a

mixture of neat cement and permitted to harden in a shallow tray of water.

TO MAKE GLAZED CEMENT SURFACE it is important that these steps be watched:

1st. That the surface be roughened wherever the glazed surface is to appear.

2d. That the tile be soaked in clean water until it has fully absorbed water.

3d. That a little dry neat cement be placed on the spaces to have glazed effect.

4th. That the neat cement should be sifted and dripped on with a brush and not gone over a second time.

5th. That the tile is taken out and dried and the glazed and dull neat cement will create the change of surface texture as planned.

A bloom or chalk-like powder often comes on the surface of tiles, but will disappear within a short time and need not cause any anxiety.

GLAZED RELIEF LINE TILE is made by casting either a neat cement tile or a concrete tile with a relief line design and then mixing a neat gray or color cement glaze and putting it onto the surface. The tile is shaken in a level position until the entire surface is entirely covered leaving a thin layer of the glaze in the spaces between the lines as well as slightly on the lines. The tile is set in a shallow layer of water to harden.

OTHER VARIATIONS IN TILE EFFECTS can be made by combining these methods and with the use of color in these different methods described, unlimited avenues are opened to the worker in color cement. It should be remembered also that most of these methods of surface treatment are also possible in other forms beside flat or tile surfaces. The student should know these methods of working with plain cement and concrete as they are the foundation of successful Color Cement Handicraft.

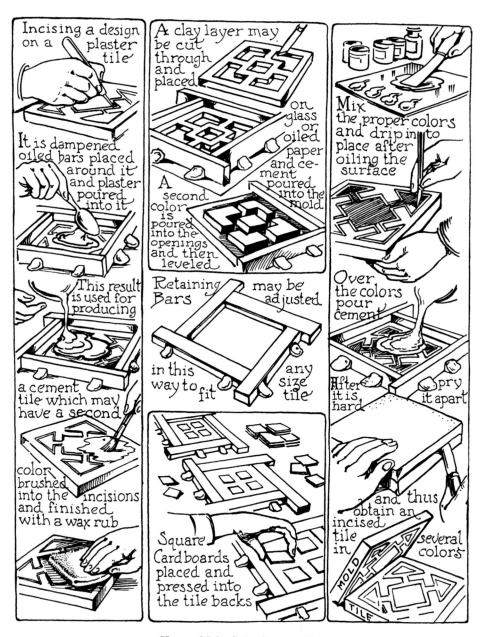

Incising a design on a plaster tile

It is dampened oiled bars placed around it and plaster poured into it

This result is used for producing

a cement tile which may have a second

color brushed into the incisions and finished with a wax rub

A clay layer may be cut through and placed on glass or oiled paper and cement poured into the mold

A second color is poured into the openings and then leveled

Retaining Bars may be adjusted in this way to fit any size tile

Square Cardboards placed and pressed into the tile backs

Mix the proper colors and drip into place after oiling the surface

Over the colors pour cement

After it is hard

pry it apart

and thus obtain an incised tile in several colors

MOLD

TILE

How to Make Color Cement Tiles

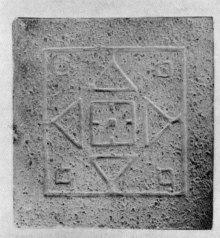

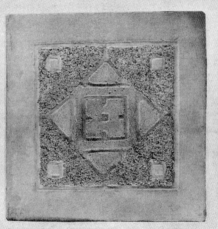

Gravel and Cement
*producing a
rough texture.*

Gravel and Cement
and Sand and Cement
producing two textures.

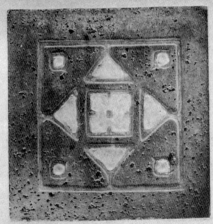

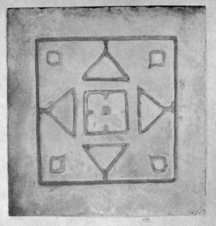

Gravel and Cement
Sand and Cement
and Neat Cement
giving three textures.

White Cement and
Gray Cement *giving
two tones as well
two textures.*

Cement Tile Textures

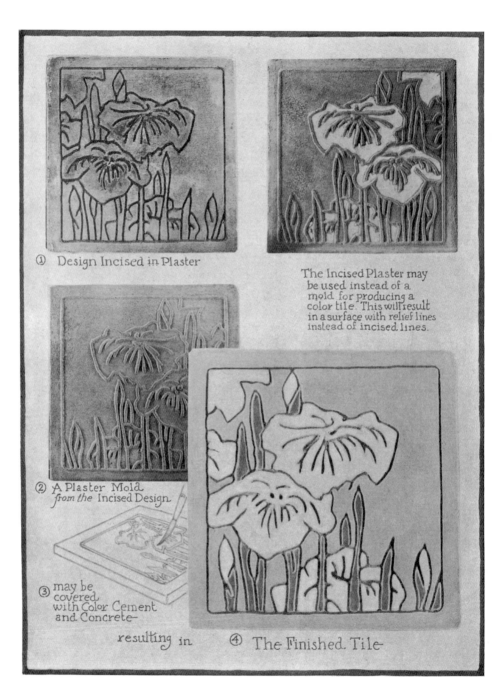

① Design Incised in Plaster

The Incised Plaster may be used instead of a mold for producing a color tile. This will result in a surface with relief lines instead of incised lines.

② A Plaster Mold from the Incised Design

③ may be covered with Color Cement and Concrete—

resulting in

④ The Finished Tile

The Incised Tile

CHAPTER 4
Making
Vases and Bowls

MAKING VASES AND BOWLS is a little more complicated than the making of tiles, but by following the directions carefully it will be found that once the process is worked out, it can be easily repeated.

FOUR DEFINITE OPERATIONS are necessary to produce a bowl or vase and they may be termed as follows:

1st. Making or preparing the original model.

2d. Making the molding case from the model.

3d. Pouring the concrete into the molding case.

4th. Releasing the mold and completing the object cast.

THE FIRST STEP, making the original model, is as follows: With clay or modeling wax build a form of the vase or bowl desired. The inside need not be considered; that is, do not make the form hollow but build it solid. Care should be taken to see that the contour is even and alike when viewed from all sides. A templet cut from metal, wood or stiff cardboard, will help in securing perfect contour if moved around on the outside and corrections made accordingly. A false neck should be added onto the solid form and part of the bottom of the mold scraped so as to leave a rim or edge on the bottom. The form is then ready to make a mold from it.

ANY VASE OR BOWL CAN BE DUPLICATED in cement by making a plaster mold from it. The inside of the bowl should be filled with sand or wadded paper and a false neck built over the mouth with clay or modeling wax. If the surface is glazed it need not be oiled before casting, but all dull or rough surfaces should be oiled.

THE SECOND STEP, making the molding case, is as follows: Take the model (clay or vase to be duplicated) and place it upon an oiled glass or other smooth surface. Marking off about one-third of its diameter, build a narrow strip of clay or wax on two sides from top to bottom. This ridge or wall should extend far enough out to meet

the molding case or metal strip, and the two walls of clay and the metal or case should be made proof against the plaster running out anywhere, when it is poured into this well. After the plaster is set, the clay strip can be removed from one side and the exposed plaster edge is oiled after two keys have been bored into it with a pointed metal strip (see working plate). The removed strip is then built along the next division of the model and the case or metal used for retaining wall is moved into new position and a second third of the molding case is made. To make the third or last piece of the mold the two first sections are retained in position (always boring keys and oiling exposed edges), the case or metal wall again placed in position and the plaster poured into the opening. The plaster should not be too thin and if a little is poured into the bottom and allowed to set before pouring the whole amount, it will not be forced out through the bottom. Of course all openings must previously have been stopped with clay or wax.

TO STRENGTHEN A MOLD strips of burlap or wire screening can be imbedded in the plaster while it is soft. This makes a durable mold capable of withstanding much handling.

TO MAKE THE MOLD FOR THE BOTTOM the three sections are turned upside down (the model still being in position) and the plaster parts all being oiled, a ring of clay is placed around the bottom so as to make a cup shape into which the plaster is poured.

THE THIRD STEP is the most important part as the mixture or "slip" for the pouring is important. The first mixture should be neat cement and water and should be rather thick, for if too thin it will not adhere to the walls of the mold. When the neat cement is ready it should be poured into the bowl about half-way full. The bowl is then rotated in a horizontal position gradually downward so that the surplus cement slip will pour out of the mouth back into the pan or container in which it was mixed. Then after a half-hour or so

another mixture of slip should be rotated. This mixture should be composed of a one-third cement and two-thirds sand mixture and be thinner in consistency. If the bowl is large and the walls need to be thick a third and fourth layer may be necessary.

THE LAST LAYER OF SLIP can be of neat cement which will finish the inside with a smooth surface. When working with color the first rotation and the last may have color added to the slip which will result in a color finish on the inside and the outside of the bowl or vase.

THE FOURTH STEP or releasing the mold, should occur the second or third day after the pouring has taken place. This elapse of time depends all upon weather conditions. In summer cement dries more rapidly and not so well. In winter the hardening is more slowly accomplished but more perfectly.

THE DRYING OF CEMENT is best when it occurs gradually. Never place cement in the sun or use artificial heat to force it. Checking, cracking and breaking will surely result if this is done.

For this reason the tiles and pottery made with cement should dry gradually in the shade but not in a draughty location.

To release a vase or bowl from the mold, the cords are untied and the plaster mold parts opened. The cement cast, if successful, will separate from the mold without trouble. The ridge that may have been formed by the groove where the plaster parts have come together can be scraped off and smoothed by rubbing the finger tips over the surface. The surplus part of the neck can be carefully scraped away and after the vase has dried out of the mold for a day it can be put in a bucket or tub of water to harden for a few days or a week.

TO FINISH A VASE it is removed from the water, permitted to dry well, the surface is brushed clean and it can then be waxed or surface finished as described in another chapter of this book.

A RELIEF DESIGN ON A VASE SURFACE requires care in making the sections of the mold so that the vase cast will pull out of the mold without breaking. If the molds are made in three or four segments there is little danger of trouble but wherever there is relief surface or lines on the surface, a two-piece mold is sure to result in the breaking of parts.

DIFFERENT TEXTURES IN GRAY CEMENT can be secured on the surfaces of bowls and vases by using almost any of the processes described in the previous chapter for tiles.

IN ADDING COLOR TO DIFFERENT TEXTURES of cement in Cement Pottery the color or neat cement can be added to the oiled surfaces of the plaster molds before they are tied together preparatory to the pouring. In this instance, however, the divisions of the plaster molds should be planned so as not to break through the designs. If a continuous design motif is essential, the only way to correct the break will be to touch in the disconnected parts with the right color or mixture after the parts of the mold have been placed together just previous to the pouring in of the slip for the first rotation.

THE MAKING OF FLAT BOWLS simplifies the rotating problem and in many shapes the slip can be placed and directed with the use of a brush. After the last slip has been added to a bowl, a design can be added with a brush by using a different color, placing the color slip in the center of the inside portion of the bowl. This can also be done on the outside surface of any bowl or vase, creating a change and surface enrichment.

VASES WITH SQUARE SIDES should be produced from plaster molds which have the connecting lines coming on the corners. In this way the casting lines that always show to some extent on the cast surface when it is removed from the mold, will occur where it will be easy to remove them and if a little does remain it becomes a part of the corner.

If any incised lines or relief parts are on the sides of these square formed vases, a separate piece for each side will be necessary in the plaster mold.

A GLAZED FINISH can be produced by rotating a bowl or vase in a mixture of neat cement that has been well sifted and placed in a pan in a thick enough layer to permit the bowl or vase to be turned in it without the sides scraping the bottom of the pan.

WHERE LARGE RELIEF SURFACES are to be produced and undercut surfaces molded, it is then necessary to use glue for the molds. This requires skill in handling. For those who wish to produce molds for such work the following is given:

After modeling the surfaces or figures in relief, if they are to be used on garden pottery, book-ends, vases, etc., or any design that has undercut surfaces, it should be covered over entirely with a one-half inch layer or blanket of wet clay or modeling wax. If the modeling has been done in clay it should remain overnight without the usual wet cloth over it, before placing this second clay layer. If wax is used the clay layer can be placed over it without waiting. Deep sections should be lightly filled with clay to reinforce the one-half inch layer. Two or three nails should be used to hold the original firmly to a board base. A little plaster-of-Paris should be poured around its base to help make it firm.

Over this clay blanket lay a strip of clay along the highest part or equator of the surface, so that the surface is directly in line with the equator. Place a casing around and fix so that plaster can be poured, and a rough casing produced of one half. Remove the clay strips and with a pointed piece of metal bore several holes or "keys" in the exposed edge of the plaster. Oil this edge and cast the second half.

Before pouring the plaster a clay cylinder should be placed at the top to form a hole for pouring into and a second hole near it for an air escape.

After the plaster is set it will be found that a casing or shell is produced which when placed over the original model (the one-half inch clay blanket having been removed) will leave a space around the entire original model.

The next step is to prepare the casings and pour the glue into this space to produce a mold of the object and its immediate surface.

A few pencil marks are made on the outside of the casing and carried onto the table or board base to check up its relation when it is replaced. These marks are very necessary.

The casings are then given two coatings of shellac and wood alcohol (one part alcohol, three parts shellac), and when dry are oiled well or greased with axle grease. Shellac is also applied to the original model whether clay or plaster. Plasticene or similar wax need only be oiled slightly.

Replace the cases so that the two halves come together closely and so that the marks on the outside lower edge correspond correctly with the marks on the table. Stop the cracks on the casing with clay dipped in plaster and bind over the casing in the same way (or with the use of cords) to prevent the glue from floating the casing.

THE GLUE IS PREPARED as follows: White fish glue or gelatine glue is washed well in water. Put in dry can, placing it in second pan of water and boil until creamy in consistency. When the finger can be dipped into it without burning, the glue is poured into the casing as follows:

A funnel of clay or wax is roughly made and the glue poured into the opening of the casing, filling the space between the model and the plaster casing.

Let stand for twelve hours. Remove casing and cut the glue shell along the half-mark made by the equator division, cutting from the under side through at one stroke. The glue can be lifted (as it will give) so as to permit cutting from underneath. To cut from the outside will not produce a clean cut.

With French chalk or talcum, chalk the inside of the plaster casing well over the shellac and fit the glue shells back into each half. Then with a solution of powdered alum and water (two teaspoonfuls in one-half cup of water) brush the entire inner surface of the glue to harden the surface. Let stand for one hour.

IF CEMENT IS TO BE USED, the glue must receive two coats of white lead or varnish and left to dry two days. When plaster is used no white lead or varnish is necessary.

Cement should be used thin and a thin layer produced by pouring into this mold and revolving it so that a coating will stick to the surface. After setting for twelve hours more is added and again revolved until the desired thickness is produced.

Where the object is not to be hollow the cement is poured in solid and left until hard enough to remove the casing and glue shell.

This sounds complicated but it is no harder than the usual recipe and if you can't follow a recipe or be interested in its result, then there is no hope for you in Color Cement Handicraft.

A DIAGRAM ILLUSTRATING GLUE MOLDS is shown at the end of Chapter Two, on The Making of Plaster Molds. A little study of this with the above directions will make the process clearer.

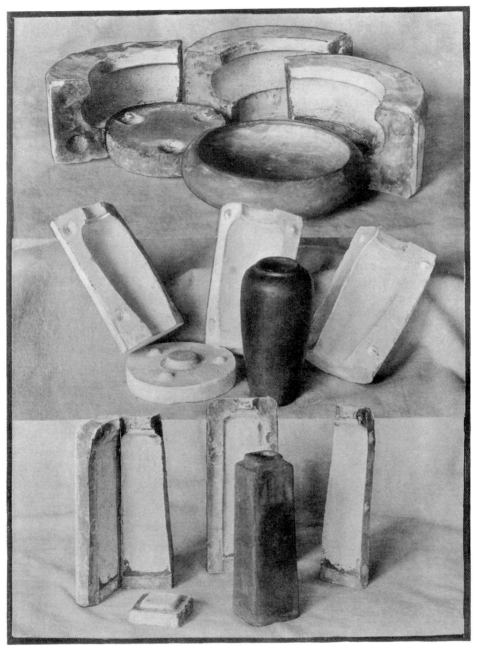

Vase Molds

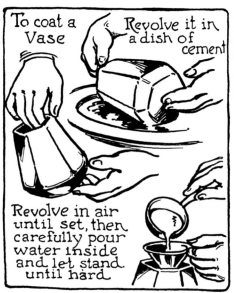

To coat a Vase

Revolve it in a dish of cement

Revolve in air until set, then carefully pour water inside and let stand until hard

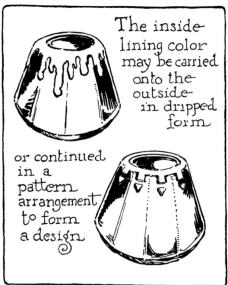

The inside lining color may be carried onto the outside in dripped form

or continued in a pattern arrangement to form a design

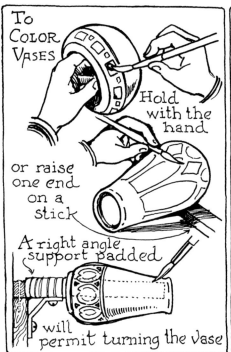

To COLOR VASES

Hold with the hand

or raise one end on a stick

A right angle support padded will permit turning the Vase

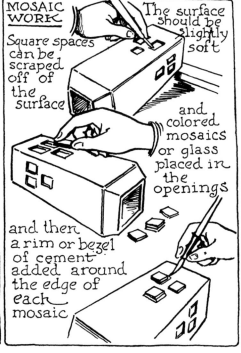

MOSAIC WORK

The surface should be slightly soft

Square spaces can be scraped off of the surface

and colored mosaics or glass placed in the openings

and then a rim or bezel of cement added around the edge of each mosaic

The Finishing of Cement Pottery

CHAPTER 5

The Use of Color in Cement Tiles

SUCCESSFUL COLOR IN CEMENT WORK is dependent entirely upon the use of mineral pigments in dry powder form. The lime action in the cement will nullify and disintegrate any color of a vegetable or chemical source so that no hue remains.

A LIMITED RANGE OF COLORS is therefore presented to the worker in Cement with which to secure results, but the list of colors described in the following paragraph is after all an elaborate one when compared with the few pigments with which the primitive and aboriginal potters produce most beautiful results in their wares.

PICTORIAL OR REALISTIC DECORATIONS ARE NOT DESIRABLE as Color Cement decoration and it is hoped by the authors that those who follow the technical direction of this book will be in harmony with the applied design principles set down in the last chapter; and that their color cement productions will be such that it will add correct line, form and color to this new handicraft. This will enable its growth among the art handicrafts to be without handicap or prejudices resulting from its use in incorrect design or application.

THE FOLLOWING COLORS ARE POSSIBLE in mineral colors for us in Color Cement: Black, Brown, Red, Dull Yellow, Blue, Green.

A Color Scale and Mineral Colors are as follows:

Color	Mineral Colors
Black or Gray	Germantown Lampblack Carbon Black Black Oxide of Manganese Black Oxide of Copper
Blue	Ultramarine Blue Oxide of Cobalt
Yellow	Yellow Ochre Chromate of Lead
Orange	Mineral Orange
Green	Chrome Oxide of Copper Carbonate of Copper

Brown	⎰ Roasted Oxide of Iron ⎱ Burnt Umber ⎱ Metallic Brown
Red	⎰ Indian Red ⎱ Venetian Red ⎱ Mineral Turkey Red ⎱ Raw Iron Oxide

THE SUCCESSFUL USE OF COLOR IN CEMENT depends entirely upon the true proportion of color to the cement. No exact rule can be quoted as colors vary in quality in different localities. Experimenting only can solve the correct proportions. Also, anything that will nullify the action of disintegration upon the color by the lime in the cement is desirable. The Petroma Cement Colors made by the American Crayon Company of Sandusky, Ohio, fulfill these requirements for the craftsman, and will aid in successful schoolroom results, avoiding loss of time and waste of material.

COLORS MAY BE GLAZED, MAT OR DULL FINISH according to how and when it is placed on the cement tile. Each finish requires different treatment and the easiest is the Dull Finish.

THE DULL COLOR FINISH is produced when the color is dropped or placed into the mold and concrete or cement is used as a backing. This results in the color drying in the mold with a dull finish next to the plaster mold surface and is exposed when the cement casting is released from the plaster mold.

THE GLAZED COLOR FINISH is more difficult to produce successfully and is secured only in that color that is placed onto tile or pottery surfaces after the cement surface has partially hardened. A tile design or pattern may be cast in a mold and after it has come out of the mold it is dried for an hour and then placed in water. If the surface to receive color has been roughened or lines scraped into it when first released from the mold and the cement slightly soft, the color will adhere even more surely. We know that metal craftsmen

often roughen the surface of metal where enamels are to be placed and fired in, to insure more perfect attachment, and a similar treatment to the cement will do likewise for the cement color. When the cement tile has been removed from the water and surplus moisture shaken off a little plain neat cement is placed on the surfaces to be colored and to this the color in thin paste form is dripped from a brush. No back stroke is possible without injuring the finish. Finish each section and then leave it alone.

A SAFE WORKING METHOD is to place the tile in shallow water to avoid any part becoming dry while the color is being applied. A pan or shallow dish will serve the purpose.

THE MAT FINISH is produced the same as for the Glazed Finish excepting that the tile is placed in water immediately after it is removed from the mold and placed there for a few minutes only. The surface is treated otherwise similarly to the glazed process and this results in the color being dull in finish.

HARDENING IN WATER should be done with all tiles and the dull and glazed finished tiles should be set in a pan of water without letting the water reach the decorated surfaces.

A COLORED SKETCH should be made in every instance where color is to be applied to cement.

MATERIALS FOR MIXING COLORS are as follows: Two sizes of small sable-hair brushes, a palette knife (or putty knife), several small dishes, a spoon, a fine-mesh sieve, and a piece of glass.

TO MIX THE COLORS proceed as follows: Place a little of the desired color on the glass, to this add dry cement reducing the color intensity to the desired strength. Portland cement being gray will do this harmoniously. To this add a few drops of water until the color is of the desired consistency.

The color should always be tested on a tile surface and dried in the sun to determine final color, adding color or cement to the wet

mixture to correct the color. Where a tint of color is wanted a white cement should be added instead of Portland cement.

To produce a plain surface color on tiles, the desired quantity of color is mixed and strained, to eliminate all coarse particles. The mixture may be sifted while dry or strained after the cement has been added.

THE USE OF WHITE CEMENT should be limited because white cement is not as durable as gray cement and because its setting qualities disappear as it becomes older more rapidly than gray cement. If perfectly fresh it can be used with good results and produces a more brilliant color when mixed with the colors than when gray cement is used.

TO APPLY THE COLOR either in the mold or to the surface of the object after it is removed from the mold, the color should be applied with a brush.

AS A TEST COLOR PROBLEM use an incised pattern plaster mold and the colors may be planned for the incised tile as follows: Working from a color sketch, mix up colors to match and after the plaster mold has been water soaked it should be oiled by dabbing the brush up and down on the surface. If the brush is stroked it will not leave enough oil on the surface and the color will stick to the tile. Next drip the cement color from a brush with a shaking motion. The various colors are thus placed in each of the partitions of the mold and after drying for fifteen minutes is backed with a layer of plain cement and sand and allowed to set.

When the tile is released it will contain different colors between the incisions and a thin wash of an additional color may be added to fill the incisions.

COLORS CAN BE MIXED one with another while dry or when wet to produce other shades. Violet will be produced by the mixture of mineral orange and ultramarine blue.

PLAIN SURFACED TILES MAY BE COLORED by pouring in a thin layer of color combined with neat cement and then backed up with a concrete mixture. Mottled and variegated color surfaces may be secured by first spattering or dropping drops of another color into the mold before the color mixture is poured in. Or the plain cement or concrete tile can be removed and covered with a color layer which will be dull or glazed in finish.

A PLAIN TILE TO BE APPLIED WITH COLOR should be placed in water immediately on being removed from the mold, and allowed to remain there for a quarter of an hour, before applying the color. When taking the tile out of the water do not let the fingers come in contact with the surface to be colored. Let the tile stand a few minutes to drain, before applying the color. Then a thin layer of neat cement mixed with water is applied. Next place a spoonful of the color upon the surface of the tile, slightly shaking the tile while level, then pour off the surplus color as it overflows the edges. If bubbles occur the surface should be recoated for the bubbles will break in the drying, producing a defect. To prevent bubbles, the color should be stirred with the spoon slowly so as to avoid the arresting of air which produces the bubbles. The point of a pin will often help to dissolute the bubbles if used immediately after the surface is coated. When satisfactorily coated, place the tile carefully in a tray and add water until it reaches a little more than half way up the side of the tile. Be careful that water is not splashed or dropped on the newly coated tile, for this will ruin the surface and necessitate doing the tile again. The tile should remain in this water for four or five days, water being added when it has become absorbed or evaporated.

TO COLOR AN INCISED DESIGN the plaster cast from the original becomes the mold for the color cement tile. The plaster, having become thoroughly dry, is shellaced with one or two thin layers of shellac and after drying for one or two days is ready for use with color cement.

It is then oiled well but not so that surplus oil remains on the surface. A dry brush will be good to use for removing surplus oil. The color having been mixed to harmonize with the previously prepared color sketch, one of the color mixtures is taken up with a brush and dripped with a shaking motion onto the correct area, which in an incised design is divided into spaces. If a drop of color falls where it is not wanted, take a clean brush and pick the color out of the space, after which a little oil should be brushed carefully into the space to renew that which was removed with the misplaced color. If any color falls onto the back of color already placed do not worry over it as it will not appear on the finished surface.

ANY COLOR NEXT TO A FILLED SPACE may overlap the previously filled space as only that color touching the plaster surface will be visible when the tile is removed from the mold and is finished.

AFTER COVERING THE ENTIRE SURFACE WITH COLOR let it remain for half an hour before backing it up with the concrete mixture, as otherwise the weight of the concrete may force gravel particles through the thin color deposits and mar the face of the color design.

TO COMPLETE THE TILE remove after two days, and place in water after the edges and slight faults have been corrected. It should harden in water for several days and then dry in a cool place after which it can be waxed or finished in other ways.

ANY OF THE PREVIOUS PROBLEMS described in the methods for producing tiles in plain cement can be carried over into this chapter and color added to the texture finishes in cement and concrete and many interesting finishes developed.

OLD COLOR AND CEMENT or dried cement color should not be used. Mix up only enough color for immediate use as any color not used fresh after mixed with cement cannot be used again and should be discarded.

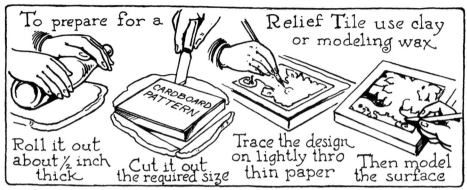

To prepare for a Relief Tile use clay or modeling wax

Roll it out about ½ inch thick

Cut it out the required size

Trace the design on lightly thro thin paper

Then model the surface

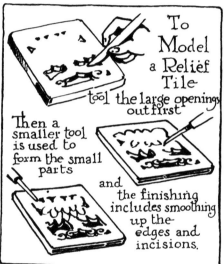

To Model a Relief Tile

tool the large openings out first

Then a smaller tool is used to form the small parts

and the finishing includes smoothing up the edges and incisions.

To Reinforce a Tile, cut a section of wire cloth

and drop into the concrete backing

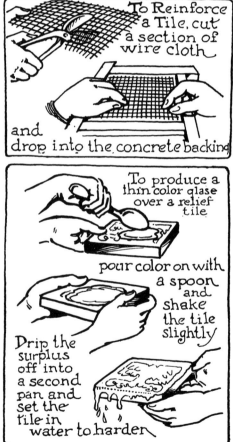

To produce a thin color glase over a relief tile

pour color on with a spoon and shake the tile slightly

Drip the surplus off into a second pan and set the tile in water to harden

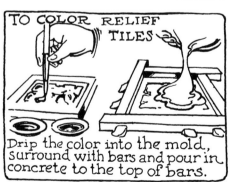

TO COLOR RELIEF TILES

Drip the color into the mold, surround with bars and pour in concrete to the top of bars.

Use of Color in Cement Tiles

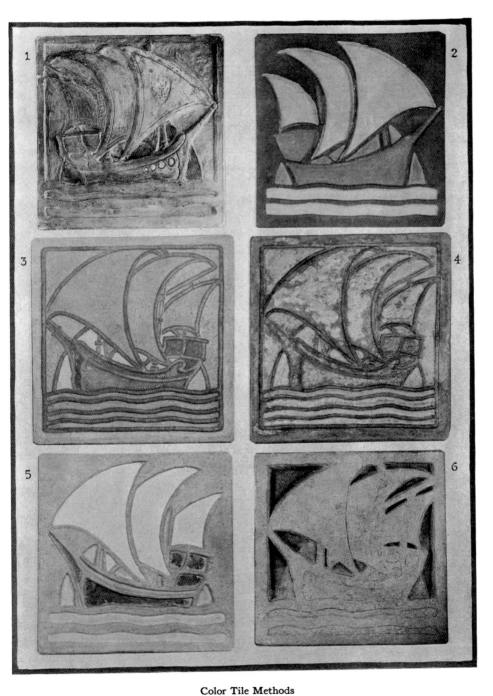

Color Tile Methods
1. Relief Tile. 2. Persian Relief. 3. Relief Line with Mold Color
4. Relief Line, Majolica Color. 5. Intaglio Tile. 6. Sgraffito Tile

Sixty-five

CHAPTER 6
Color Cement Relief
Tiles

TO BEGIN A RELIEF TILE, a model should first be planned on clay or modeling wax. A pencil pattern is first made on paper and this paper is placed over the layer of clay or wax and a pencil tracing will produce an indented pattern of the subject on the clay or wax underneath.

TO MODEL THE SURFACE a wooden modeling tool, such as is used by sculptors, or a leather modeling tool or even small whittled pieces of wood can be used. In producing raised portions the clay or wax scraped to produce low parts can be used and care should be taken not to produce too great a relief as a tile design should not appear detached.

AVOID UNDERCUT SURFACES or overhanging edges on the finished model as this will result in locking of the cement cast with the plaster mold and breaking of the tile before it can be removed. A general checking over of the different parts before the plaster cast is made will avoid many of the overhanging parts going through as they can be easily located and corrected.

TO CAST THE PLASTER MOLD the clay or modeling wax is surrounded with the retaining bars and as the clay or wax needs no oiling the plaster can be mixed and poured into this mold. A slight jarring of the table or surface on which the mold is placed will cause the plaster to settle, producing a level surface and also cause any bubbles to break or come to the surface.

TO AVOID BUBBLE DEFECTS IN CASTING either with plaster or cement the plaster or cement mixture should be poured into the center location of the mold allowing it to spread gradually toward the sides and corners carrying the air in the grooves and low spaces, forcing it toward the edges. Once the surface is covered in this way the remainder of the mixture can be poured in more rapidly.

TO CORRECT BUBBLE DEFECTS that appear on the finished plaster or cement casting, scrape some of the plaster or cement from the back or sides where it does not matter and repair the flaws by pressing it into the holes. Where cement is repaired this way it should be permitted to dry for another day before it is placed into water to harden.

TO MAKE THE CEMENT RELIEF TILE in color the plaster cast made from the clay or wax model should be oiled after it has been shellaced and surrounded with the retaining bars. The color should be then mixed with the cement and water added to make it of a pouring consistency, it is then poured into the mold. After this color has set for awhile the back layer is added of concrete after the color of the first pouring has been carried up so as to produce color on the sides as well as on the face.

WHERE A NUMBER OF COLORS ARE USED the colors are mixed and dripped upon the oiled surface of the plaster mold before it is enclosed with the retaining bars, as the retaining bars would prevent free access to the surface with the brush. After the various colors have been placed, the plaster cast is then placed within the bars and the color being permitted to set, it is then backed with a layer of concrete.

THE CONCRETE BACKING MAY BE COLORED either with color throughout or with a topping of color to give it a finish. If corners are to be rounded or the edges trimmed in any way this color layer should be thick enough to permit trimming without exposing the under layer.

TO AVOID THE COLOR FALLING OUT in color relief work, the following should be observed. When preparing to pour in the backing, observe whether any of the color cement placed on the tile has become too dry. If so, it should be sprayed with a light coating of water or brushed with a brush full of water, and its upper exposed

surface slightly roughened so that the backing will adhere firmly. If it becomes dry and smooth the second layer of cement poured onto it will come in close contact but not adhere, and later a change in temperature or jar of the tile may shake a portion of the design loose so that a color fragment will fall out.

TO AVOID COLOR PREMATURELY DRYING, the plaster cast should be placed in water for fifteen minutes at least before the color is placed into it. To permit free absorption of water the plaster tile should never be shellaced on the bottom but only on the sides and the top.

ANOTHER WAY TO MODEL A RELIEF DESIGN is to carve it on plaster direct without making the relief on clay or modeling wax. This method has the advantage of being proof against over-hanging edges, though some care must be taken against undercut surfaces.

TO MAKE THE PLASTER CARVED MODEL trace the design onto a smooth slab of plaster of the right size that has been cast on a smooth surface. If a larger piece of plaster than the desired size is used it can be cut down.

TO CUT PLASTER SECTIONS an old saw can be used or several strokes of a knife on the surface until about one-quarter of the thickness has been cut, and a similar cutting on the reverse side, just opposite to the cutting on the first side will enable the plaster to be broken easily. Or by laying it on a straight edge with the line of cutting over the edge, a quick pressure with the hand will snap the two pieces apart.

AFTER THE DESIGN IS TRACED a chiseled nail point, nut pick or other hard edged point is used for scraping the surface of the plaster, modeling it or carving it to the desired shapes. Naturally it will be found that plaster can only be taken off and not added on and

that all reliefs must be produced from the surface downward, that is the natural surface will be the maximum height and all variations in the surface produced below that.

BACKGROUND TREATMENTS are produced where a design appears in low relief against a background. The background may be stippled with the tool point or lines scraped or crossed lines used to create interesting background qualities.

TO BUILD UP PLASTER SURFACES, roughen the surface onto which more plaster is to be placed and mix fresh plaster and place it on with a small spoon or with the brush. After this is dry it can be carved or scraped with the tools used in the modeling of plaster.

TO FINISH THE PLASTER CARVING, it is dried, shellaced, and used for casting just the same as the other relief forms described. To preserve casts from receiving injuries to their surfaces they should be wrapped in paper with a card against their face and placed with face toward the wall in a cupboard or shelf, when not in use. Where a mold has been repeatedly used and the shellac become worn, the mold should be carefully dried and the shellac coating renewed.

A CONVENIENT CLAY TO USE for relief work is the powdered fire clay secured in most hardware stores and is the clay used for lining grates, furnaces and similar purposes. This clay is convenient in that only the amount needed may be mixed up for use, leaving the balance of the powdered fire clay always in good condition.

RELIEF TILES DESIGNED FOR FLOOR SURFACES or for wall surfaces are best where they do not contain deep relief as they will not catch dust or dirt and will be better unified with the remaining surfaces.

SPECIAL TREATMENT FOR RELIEF FLOOR TILES is required in that the cement should be compact and clean sand should be used mixed with just enough water to cause the two to adhere to

each other and this should be tamped into the mold well up against the face of the plaster tile to pack the mixture firmly and cause it to form into a durable surface.

TO HARDEN CEMENT TILES or pottery they should be placed in water so that the water will complete the chemical action producing the stone-like quality of successful cement work. If the tile is removed and dried and again placed in water it will increase the hardness.

AFTER THE TILE IS HARDENED it is dried thoroughly and brushed well with a brush. It may be waxed or first given a thin coat of shellac and then waxed. Shellac should never be applied until the cement tile is thoroughly dry, as otherwise the shellac will remain sticky.

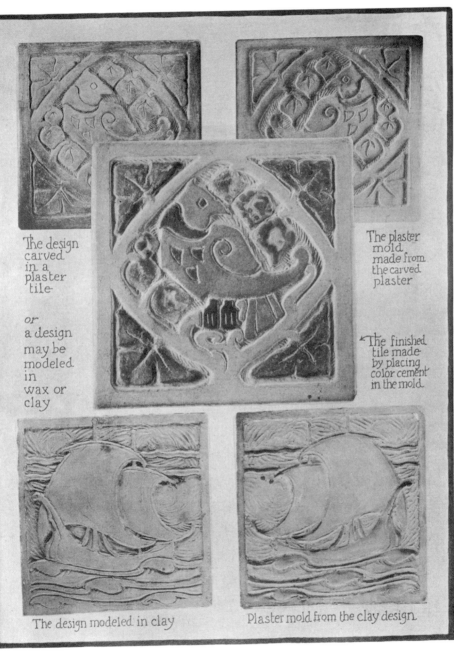

The design carved in a plaster tile-

or a design may be modeled in wax or clay

The plaster mold made from the carved plaster

The finished tile made by placing color cement in the mold

The design modeled in clay

Plaster mold from the clay design

Plaster and Clay Modeled Cement Tiles

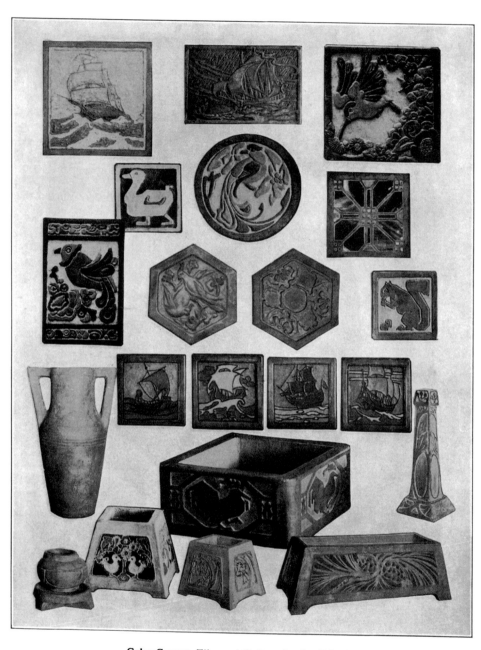

Color Cement Tiles and Pottery by Art School Students

CHAPTER 7

The Majolica Tile

MAJOLICA POTTERY derived its name from the island of Majorca, Italy, where during the sixteenth century glazed pottery reached its highest perfection.

Glazed color may be placed in hollows in the surface of pottery or on the surface. A better method is to produce a raised line or rim to retain the glaze, and this is the method we will use in the cement or concrete pottery.

THE CEMENT MAJOLICA TILE is made as follows: First design a subject that will have each motif, part or section defined with lines. These lines must be part of the design and used much as lines are used in stained glass work. The design should be simply planned. A confusing overcrossing tangle of lines is to be avoided. A few geometrical forms rightly related will be most pleasing. Keep the design at least one-half inch within the edge of the space. Then oil a piece of glass as directed, place over a card that has the tile dimensions squared off on it as a guide for placing the casting bars on the glass. Clay or wax should always be used to hold the casting bars in place. Into this now pour plaster-of-Paris, pouring into the center, letting it flow to the outer edge. Level off evenly and remove after fifteen minutes. On releasing this plaster tile a smooth surface will be found on the side which came next to the glass.

THE DESIGN is then transferred to the plaster tile by tracing with a carbon paper. The paper should be thumbtacked onto the sides of the plaster tile to prevent it from slipping while tracing. The design should also be traced on backwards so that the completed majolica tile will be in the same position as the design. The design is then incised with the incising tool, care being taken that at whatever depth the line is made the incision has sides sloping upward. If these grooves have overhanging edges the cement to be poured in will flow under these edges and lock the tile, causing these lines to break before the cement tile can be released.

WHEN INCISING, see that the bottom of the groove is sufficiently wide, as this bottom is to be the surface of the line on the completed surface. A line one-sixteenth or one-eighteenth of an inch is not too wide. The plaster should not be too soft or too hard to secure the best incision and avoid crumbly lines. When the incising is completed oil the surface and surround the tile with four retaining bars. The bars should be soaked in water and be of double width as they extend above the plaster cast. This extension above the tile represents the thickness of the tile to be made. Clay or wax is pressed on the outer edges of the bars and plain neat cement or a mixture of the desired color is made and poured onto the mold. Pour in the center steadily, for cement poured on the "installment plan" will show a mark wherever each installment occurred.

When the cement in the mold has dried for twenty-four hours remove by slightly prying, after the retaining bars have been removed. If parts of the lines are not on the surface it is because air was arrested in pouring the cement or the oil settling in the grooves. If lines are broken and remain in the mold it is because the grooves have overhanging edges and locked the cement line. To repair these lines, soak the tile for a few minutes and mix a small portion of cement to match that used and build the missing section by dripping the cement from a brush.

AFTER DRYING for an hour put the whole tile in water for a day or overnight and it is then ready to add the color. Meanwhile the plaster mold with the defective grooves should have the grooves cleared by scraping the overhanging edge with an incising tool.

The tile as it has been produced by the mold appears with a number of relief lines dividing the whole surface into a number of partitions or cells. It is into these that we are to place the color and it should be worked as follows:

While the surface of the tile is moist, drip in the color with a brush, spreading it to fill the required space. Thin pieces of metal

(or material that will not absorb the moisture) may be used to spread the color, producing a smooth, even surface. The color after once commencing to set should not be touched, and for this reason should be rather liquid so as to permit handling without too rapid drying.

THE COLOR SURFACE appears better when the lines of the design remain uncovered with color. If the color is thickest in the center of the spaces and then bevels down as it comes in contact with the lines, the whole tile or surface will appear more professional.

If color becomes blurred or disturbed, it is better to wash the whole out under the faucet and begin anew, or remove the section at fault and work over. No amount of patching or rubbing will perfect the surface after it is partly dry or completed.

After the coloring is finished put in a tray, carefully pour water into the tray without dropping any onto the tile and let harden for five days. The water should reach a little more than half-way up the side. After removing it from the water let stand until dry, polish with a soft flannel slightly waxed to remove white sediment on surface.

ANOTHER METHOD WITHOUT THE LINES is to use the color directly onto cement or concrete surface without any retaining lines. The colors may be placed so that they intermingle or so that they just touch, or the color spots may be separated one from another similar to stencil work. The color for this method is mixed thoroughly with cement and water until the mixture is a fine thick liquid or "slip."

SLIP PAINTING is a method of painting a design in one or several colors over a cement or concrete surface. The color may be slightly in relief or if done at the proper time it can be made to become a flat stain of color sinking into the first surface.

THE TWO WAYS OF SLIP PAINTING must be handled a little differently and the best way to become familiar with these

methods is to do the work. Therefore let us work out the first method of producing a design slip painted in slight relief as follows:

FIRST: Make a design for a six-inch square, the design to denote the colors to be used. Second: on a glass place retaining bars which have been soaked in water and oiled, leaving space six inches square into which a half layer of neat cement is poured and then a layer of one-half sand and one-half cement. Third: after standing for twelve hours, release this cement tile and it will be a plain, smooth surface. This is placed in water for an hour and the design traced upon its surface.

Chalk of any visible color should be rubbed on the back of the drawing to act as a tracing medium. Carbon paper or graphite should not be used as any greasy substance will prevent the slip painting from adhering to the cement tile surface.

THE COLORS FOR THE SLIP PAINTING should be mixed so as to match the colors of the color sketch. When matching the colors, dry a small dab of each color on a glass to see the dried color effect.

TO MIX THE COLORS PROPERLY, select the color you wish, emptying a little upon a glass or marble slab. Take a little clean water and mix with a palette or putty knife and grind the color until it becomes a thin liquid paste. Having ground this color thoroughly, scrape it up and place on one side of the glass, then proceed with the next color until you have mixed the complete palette of colors to match those on the sketch.

VARYING COLORS CAN BE SECURED by mixing the mineral colors and where hues different than those in the set are wanted they should be mixed the same as in water colors. There is one exception to this rule and that is in using the orange. The orange in the mineral colors when mixed with blue will produce a violet.

To gray the colors add gray cement, and to ligthen the colors add some of the white cement.

TO PLACE THE COLOR ON THE TILE, take it up with the brush and drip onto the cement surface, being guided by the tracing previously made. The color should be thin enough to flow from the brush easily and not so thick that it drips in lumps. More water should be added if too thick and more color is added if too thin. In both instances, whether water or color is added it must be ground in thoroughly. If the color settles on the glass it should be stirred again to keep the mixture uniform.

THE RELIEF OF THE COLORS can be regulated by how much color is flowed from the brush, and surfaces can be built up by repeating the strokes of color. Avoid repeating a stroke after the color has commenced to set, as a second stroke in such an instance will destroy the surface lustre. Where colors run over the boundaries they may be scraped back or taken off with a moist, clean brush.

The direct clean stroke will produce the best final results, and if preceding each stroke a little thought is given, mistakes will be avoided.

The tile surface should not be permitted to dry while working upon it and if kept in a shallow tray of water there will be less risk of it doing so. Water should never be permitted to fall upon or touch the surface of the slip painting or tile as the color will be destroyed. The tile is placed carefully into shallow water to continue hardening and in four or five days will be hard enough to remove. After drying out of water several days it is ready to use or it may be given a gasoline wash or wax rub if needed.

Tiles will harden as they age. Those that appear to be partly chalky when completed will harden in a month's time, when the moisture from the center of the tile has completely evaporated.

THE SECOND METHOD OF SLIP PAINTING is used where three different planes or heights of color are wanted. For instance we will suppose that the subject is to be a decorative design of trees and distance landscape in three colors. This would be worked out as follows: First, cast a plain cement tile and after removing it and while damp pour a spoonful of color on the surface coating it with plain color as desired. This color should be the background color of the sketch. Second, while this coating is soft, take the lightest color (for clouds, water, boats, flowers, etc.) and with a full brush place the color onto this soft coating. It will blend and sink into the background color and remain equally flat. Third, after these colors have commenced to set, with a full brush paint in the foreground part of the design (trees, etc.), working in large masses and building up the color by repeated strokes until the right relief is secured. Avoid shading the parts and keep all parts flat in tone, even though they may be in relief. It will be found that the later color is added to the first coating the less it will sink into the background. Any design can be worked out accordingly either in relief or flat. A little experimenting will solve many questions, and reveal greater possibilities. To complete the tile it is placed in shallow water until it hardens, then let dry for several days after which it may be given a toning wash, or gasoline wash, and a wax rub.

A THIRD METHOD is to take a flat surface and slip-paint a design onto it in relief. After the color has set for a short time it can be trimmed carefully with a knife so that the sides are nearly vertical. This will give the slip-painting a decidedly different appearance and it may be left this way or other color may be added so that it comes nearly up to these trimmed sides.

AVOID LEAVING ANY PART OF THE SURFACE DRYING or setting when painting on the surface; or the tile hardening in the water too long before being painted upon, as it will prevent

it from becoming durable. Surfaces can be covered smoothly when slip-painted if the color is used very thin. First cover the surface with a coating of the color to be used, immediately adding more of the color and it will flow and settle evenly.

A slip-painted color will dry dull if placed upon a tile shortly after it has come out of the mold. To secure a glaze to a color the tile should remain in the water for two days before the color is placed onto it.

FOR LARGE SURFACES on which color is to be slip-painted, the surface on which the color is to go should be roughened, so that the color will become anchored.

THREE DEGREES OF SURFACE can be secured by different treatment. These finishes are, first, Dull Surface; second, Mat Surface; third, Glazed Surface.

DULL FINISH is secured by putting the color into the mold. The mold absorbing the water from the surface causes it to dry dull.

MAT FINISH is secured by placing the color onto the tile or vase surface after the surface has come out of the mold and moistened in water for a few minutes.

GLAZED SURFACE is secured by letting the tile or other object harden in water for several days and then draining off the surplus water, after which the color is slip-painted onto the desired surfaces.

TILE SHOULD NOT BE PERMITTED TO DRY at any time before color is added, as the color will not become attached to the surface.

DO NOT FORGET to roughen the surfaces of the spaces and to add neat cement also before dripping the color onto either the mat finish or glaze finish tiles as described in chapter five in the paragraph on The Glazed Color Finish.

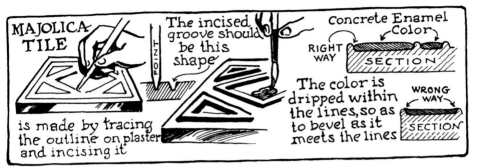

MAJOLICA TILE is made by tracing the outline on plaster and incising it

The incised groove should be this shape

The color is dripped within the lines, so as to bevel as it meets the lines

Concrete Enamel Color

RIGHT WAY — SECTION

WRONG WAY — SECTION

THE MAJOLICA TILE

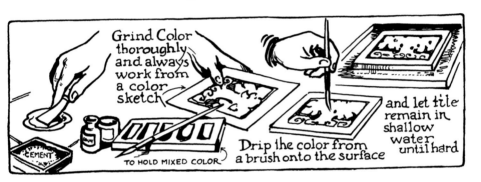

Grind Color thoroughly and always work from a color sketch

TO HOLD MIXED COLOR

CEMENT

Drip the color from a brush onto the surface

and let tile remain in shallow water until hard

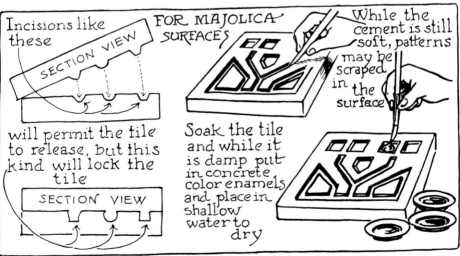

Incisions like these

SECTION VIEW

will permit the tile to release, but this kind will lock the tile

SECTION VIEW

FOR MAJOLICA SURFACES

Soak the tile and while it is damp put in concrete color enamels and place in shallow water to dry

While the cement is still soft, patterns may be scraped in the surface

The Majolica Tile

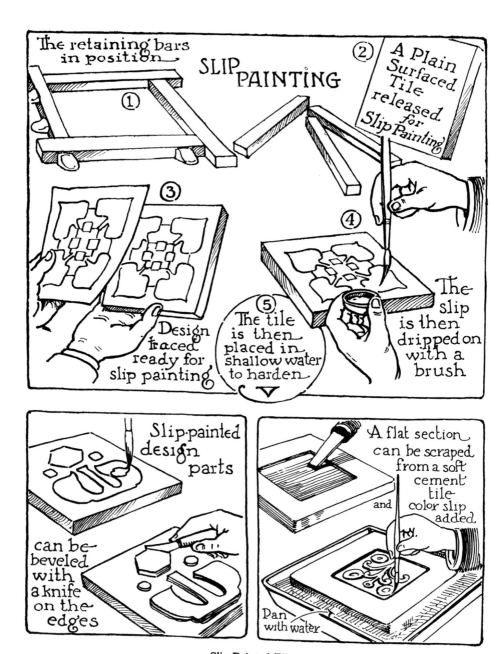

Slip-Painted Tiles

A Slip Painted Tile
*the color having been
dripped in, and the
tile shaken to flatten
the color.*

A Slip Painted Tile
*the center space
of the tile having
been scraped to
accomodate the slip.*

A Slip Painted Tile
*painted over a color
background. The slip
is left in relief.*

A Slip Painted Tile
*the colors being mixed
with white cement
onto a white background.*

Slip-Painted Tile Methods

CHAPTER 8

Sgraffito
z'grȧf-fē'tō
Color Cement Work

SGRAFFITO is the name applied to the incised ware of the Italians, and used by them from a very early period dating as far back as the twelfth and thirteenth centuries. The ware was made by covering the clay body with a layer of slip of another color, and this was then scratched through with a tool showing the color of the ware beneath against the superimposed surface, after which it was fired. This process has been used from the most primitive times, but it remained for the Italians of the fifteenth century to dignify it as an art.

COLOR CEMENT SGRAFFITO is produced with a layer of cement and color being used instead of colored clay and the cement is hardened without firing, water only being used to finish the surface to a durable quality.

THERE ARE TWO WAYS to produce a sgraffito surface on a tile and these are, the glazed surface and the dull surface tile. No mold is needed for the design as a sgraffito design must necessarily be a freehand production, though molds may be used for duplicating the sgraffito effect after the original one has been made, if no undercut edges are left.

TO PRODUCE A SGRAFFITO TILE, the retaining bars are set to give the desired shape and dimensions, after which the space is filled with a half inch layer of concrete, either of sand and cement mixture or of gravel and cement. When this layer has dried so that the top section is moist but firm in surface, a thin layer of color and cement should be poured onto the cement so that it forms a thin layer not more than an eighth of an inch thick.

TO SMOOTH THE LAYERS after the color has been poured in, shake the glass or table or whatever surface the mold is resting upon and if this is done gently it will cause the color to become level and even in surface finish.

TO CAUSE TILES TO BE EQUAL IN THICKNESS the surface of the glass or table upon which the mold rests should be level

when the cement is poured in. Otherwise the tile when finished will be found to be thicker on one side than on the other. A glass or pan of water or a spirit level will quickly show whether or not the surface is level.

AFTER THE FIRST COLOR LAYER IS POURED into the mold it is permitted to stand just long enough to settle firmly and then a second layer of another color is poured over the first layer so that it also forms a thin layer of even color. This second layer should be even thinner than the first. A layer one-sixteenth of an inch is a good dimension to plan on, though these dimensions need not be accurately adhered to. If the first layer is permitted to dry too long before the second layer is added the result will be that as the finished sgraffito tile is drying it will split in layers, the split coming between the layers of colors that were permitted to dry too long.

A THIRD LAYER OF COLOR may be added over the second layer if the design being planned calls for three divisions of colors. These layers are to respond to the next step in the process, which is to expose portions of each layer by tooling the surfaces so as to produce different colors at the same time that the different depths are produced.

THE TOP LAYER WILL DRY WITH A SMOOTH SURFACE which will produce a sgraffito tile with a glazed or partly polished surface while the other layers will have a surface with dull texture.

TO PRODUCE A TILE WITH A DULL SURFACE throughout, the pouring stages should be reversed in their steps. That is, the color that is to be the top surface should be poured first and the other colors in their proper relation, the last layer being the cement and sand or other concrete mixture. This will result in the layer first poured in coming next to the glass, having a dull finish when it is released from the mold.

TO PRODUCE THE SGRAFFITO DESIGN on the sgraffito tile, the tile should be permitted to dry for about ten to twelve hours or if it remains overnight the surface will be about right to work upon. The paper with the design is then placed and retained in the correct position on the cement tile and a dull pencil is used to trace the pattern, without the use of carbon paper or other transfer medium. This will result in an indented or embossed guide line on the cement surface of the tile which can be used in scratching away through the first layer to the under color.

THE TOP LAYER OF COLOR should be used to tell the main part of the design story. If the subject is to be that of a bird or a ship, the top layer design should be the bird or ship or other motif and the motif should be so designed as to reach the boundaries of the tile surface so as to produce a strengthening border arrangement all around the edge.

THE SECOND COLOR LAYER can then play a secondary part in both the color scheme and the design arrangement, giving with its color placing a contrast to the upper main layer used for the design.

THE BACKGROUND COLOR should be brilliant or dull depending upon the surface color. If the surface color is brilliant, the bottom color should be duller. If the upper color is dull, the background color can then be the bright intenser color.

WHERE THREE LAYERS OF COLOR ARE USED the middle layer can be a color harmonizing with both the background layer and the top layer and can be used either for a pattern part to the design or it may be used simply as a blending strata or layer appearing in the cut sides of the sgraffito work.

COLOR HARMONY is essential in producing sgraffito color cement and a color sketch will be a good safe preliminary in doing

sgraffito work as false steps or errors cannot be remedied in sgraffito and each step should be carefully thought out before the tooling commences.

TO DO THE TOOLING, a scratch point should be used for incising or scraping down along the line of the portion to be scraped out. The portion within this boundary should then be scraped out down to the next layer of color, care being taken not to gouge or cut deeply into the under color. If the design is one of three layers, the center layer can be included in the scraping out if the bottom color or layer is to appear in that portion of the design. Do not attempt in the scraping to take out large portions at a time as it will result in the breaking out of sections that are wanted as part of the remaining design. It will be found that the layers of color as scratched into retain their separate layers and that the thin layer of the upper color separates easily from the layer on which it rests. If a slight portion of the upper color is inclined to remain attached to the background color or under layer let it remain as it will give an interesting color quality and harmonize the two colors.

THE SIDES OF THE SGRAFFITO LAYERS should gradually slope outward, and after the layers have been tooled clear the sides of the layers should be gone over and evened up in slant as well as in general finish. If the corners are to be sharp or rounded in finish, see that the treatment is carried out similarly in all parts so that a general unity of finish will remain.

THE LAST STEP IN FINISH is to place the sgraffito tile in water so that it is entirely immersed, and it is left in the water for several days after which it is dried by being placed flat in a cool but not draughty place to dry.

TO PRODUCE SGRAFFITO SURFACE on bowls or other round surfaces the layers are produced by rotating the bowl in colors

or spraying the colors on with a sprayer such as is described in the chapter on coloring of bowls and vases. The color can also be placed on with a brush if it is mixed to the right consistency and the successive layers put on at the right intervals.

SGRAFFITO FOR ARCHITECTURAL WORK holds great possibilities, and is being gradually recognized by those builders who desire the charm of hand wrought enrichment that graces so many of the Old World buildings. Sgraffito decorative pillars and panels for buildings, homes and courts is an assured possibility by the use of color cement and can be produced with less cost than by the fired clay method as well as in larger, more unified sections in that there are no kiln limitations to be considered in doing the color cement. A plate is shown illustrating the use of sgraffito in the making of an entrance to a college building designed in the Italian Renaissance style and the sgraffito and ornamentation being of Italian source, both combined in perfect harmony with the building as a whole.

SGRAFFITO CAN BE APPLIED TO MANY FORMS such as book ends, fern boxes, garden bowls, the requirement for success being mainly the placing of the successive layers of color on each other when neither too dry or too wet, and the scraping away of those parts desired when the cement is in the proper condition.

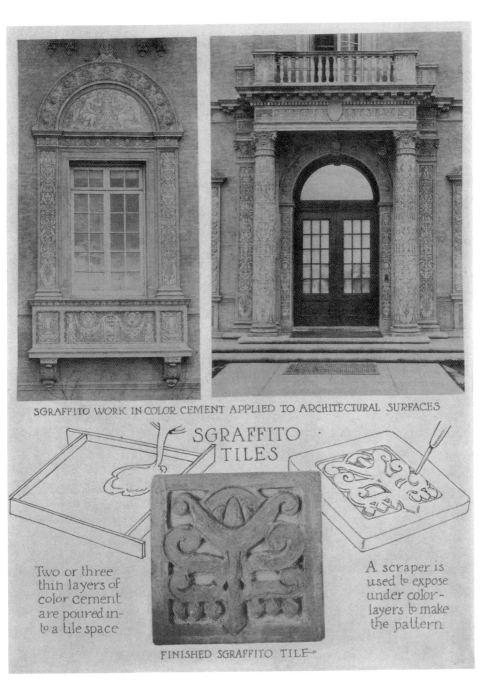

SGRAFFITO WORK IN COLOR CEMENT APPLIED TO ARCHITECTURAL SURFACES

SGRAFFITO TILES

Two or three thin layers of color cement are poured into a tile space

A scraper is used to expose under color-layers to make the pattern

FINISHED SGRAFFITO TILE

Sgraffito Tile and Sgraffito in Architecture

CHAPTER 9
Modeled and Carved
Color Cement

FROM A STANDPOINT OF GOOD DESIGN modeling, when applied to a flat surface or any other surface, should not be high in relief.

Any time that a modeled design appears to have been added onto or is in such relation to the surface that it appears to be an independent, detachable ornament to that surface, then it is not truly decorating the surface, but detracting from the object decorated.

At all times keep the principles of unity and subordination in mind when producing modeling so that the design will be a related development to the material and the surface used.

CEMENT TILES WITH A MODELED SURFACE are produced as follows: Take a flat, smooth piece of clay or modeling wax, cut to the size of the tile to be produced. Such a surface may be made by rolling clay or wax with a rolling pin or other rounded surface. Having drawn the design to be modeled on a piece of thin paper, place this over the clay and trace lightly. This will produce a slight indication on the surface sufficient to guide the modeling. If there are sections that are to be low, these parts are outlined with an incision in the surface and scraped out to the desired level.

Do this over the entire surface, bearing in mind that the edges of the tile should generally have a border or other parts retained of the original surface. Too much elimination on the tile edge will thin the tile and weaken its construction and design.

Having scraped out all the low parts, then clay or wax may be added to such parts that are to be higher than the first surface. With the modeling tool shape the parts, finishing them so that there are no overhanging edges.

When this is completed surround with the plaster bars and produce a mold in plaster which in turn is oiled in the usual way and a cement tile cast from it. Neat cement should be poured first, and after a few minutes setting, a concrete mixture is poured in until the

desired thickness is secured. In this way a cement tile is secured, duplicating in form the original clay or plaster hand-made modeled tile. The color of the surface can be any color according to the color added to the neat cement mixture.

DIFFERENT COLORS on different parts of the surface can be produced as follows: Mix cement colors with equal parts of cement. Grind these colors with the putty knife or pestle and place each color in a small saucer or pan. Oil the surface of the mold with a brush, dabbing it on in short strokes. The colors are next dripped from a brush onto their right location. This layer of color should be about a quarter of an inch thick and left to stand until firm on the surface. It is then covered with a layer of concrete and smoothed off to a level.

TEA TILES OR LARGE TILES for inserts into garden furniture or for architectural use can be strengthened by a reinforcement. A reinforcement may be made from the ordinary window screening or any wire fence mesh or so-called hardware cloths used in building construction.

This wire should be cut a little smaller than the tile and sunk into the concrete layer while soft. It should be pressed down with the fingers until the concrete closes over it. This will add a considerable strength to the tile.

After the tile has set for several days, it is removed by inserting the knife between the edges and carefully prying it apart, or steaming apart by placing over a low flame for a few seconds. If part of the color remains sticking to the plaster mold it is because there was not enough oil on that particular spot. Therefore remember that a mold surface should be well oiled before placing the color into it, and care being taken that there is not so much oil that it settles in the hollows and grooves.

The tile after drying thoroughly may be polished with wax and used.

FOR MODELING LARGER OBJECTS such as flower pots, urns or similar forms, it is best to form some means of reinforcement to approximate fairly closely the final form of the object. Close meshed wire can be used successfully for this purpose. It should be tied and braced firmly so that the concrete or cement weight will not destroy its shape. The concrete mixture should be made with one part cement and two parts clean sand.

TO HASTEN THE SETTING OF CEMENT add a very small quantity of common washing soda to the water used in mixing the cement. This will cause the cement to set up rapidly so that the work can be done more quickly.

AFTER THE MIXTURE HAS BEEN APPLIED over the wire reinforcement and shaped and modeled until completed, it should be put in some covered place or in a moist location for the first two or three days so that the moisture in it will not evaporate.

TO HARDEN THE CEMENT OBJECT immerse it well in the water for four or five days. If it stays longer in the water it will not hurt the object. The water will harden or complete the action of hydration necessary to make cement durable.

TO SECURE BISYMMETRIC SHAPES to forms or to secure true circular shapes, a templet of sheet metal can be cut and rotated from a centrally located axis. This is used while the mortar or concrete is in plastic condition so that the templet will cut or model the right contour.

CARVED CEMENT is made possible by scraping or carving out the cement when it is in the right condition. This condition can be determined by scraping the cement to see whether it is hard enough to carve. If it is too hard, it cannot be carved successfully. About sixteen to twenty hours setting will produce about the right condition but this will vary according to the mixture and climatic conditions, as temperature will be an important thing to consider in all color cement

work. Very hot weather is not a good time to do color cement, the winter days or gray cool days are best to work with cement for perfect hardening results. Avoid freezing weather.

TO CARVE CEMENT, the tools may be of metal or nails shaped with cutting points and the work done similarly to the carving of the sgraffito tile described in the previous chapter. No adding or building of parts is possible, the whole subject being a process of taking out parts and shaping the parts that are left. Backgrounds and portions can be varied in texture and different results will be secured with a little experimenting.

DIFFERENT TEXTURES are possible in the carved tile. A glazed surface to the carved tile is secured by carving on the upper side of the tile; while the dull under surface, the side molded against the glass or under surface, will be used if a dull surface for the carved tile is desired.

A GLAZED OR MAT FINISH BACKGROUND in the carved tile can be secured by immersing the tile in water for a day or two for glazed finish or an hour for a mat finish and then applying neat cement, plain or with color as described in the chapter on Color Work for Tiles.

CARVING ON BOWLS AND VASES and other forms can be done, care being taken that the carving does not go so deep as to weaken the surfaces. Motifs or spaces can be carved out of cement bowls and vases and bits of stained glass or mosaics, or color cement can be put into the spaces and neat color cement used to bind the additions into the spaces.

SLIP-PAINTED PORTIONS MAY BE ADDED to the carved tile. After the tile is carved and properly moistened in preparation for the cement to be added, the color cement is mixed to a thin slip and a background pattern or decorations can be added to the surfaces of the carved tile. The tile is then placed in shallow water without per-

mitting the water to reach the surface of the tile, and permitted to re-
main for four to six days before removing. It should then be placed
in a cool location until completely dried.

THE UNIT TILE or the small tiles made to be assembled in
patterns, may have modeled or carved cement surfaces combined with
the units to complete the pattern. For instance a number of tiles
representing leaf forms may be combined with others representing
flower motifs. These may be imbedded into a panel of cement or
concrete, the units grouped in some form of design growth, the stems
and other related portions being modeled in the cement, or carved in
the surface after the cement is somewhat hardened. The units can
be in color or mat finish, the background remaining in dull finish.

MODELED CEMENT TILES differ from the cement tile with
a modeled surface. In the first the modeling is done on wax or clay
and the cement tile is made by duplicating the effect by the use of
plaster molds. The modeled cement tile is a modeling of the cement
by hand while it is still in a plastic stage.

TO PREPARE CEMENT FOR MODELING, pour a concrete
mixture into the mold so as to allow for a second added layer of about
one quarter inch of neat cement. This last layer of neat cement is
the part which is to be modeled and can be made into a color by the
addition of color to it. This color should be added in the dry form to
the dry cement, mulled or ground well into the cement and then
mixed with water until it becomes a thick cement paste that will pour
slowly onto the concrete mixture first placed in the mold, until it covers
the entire surface. A gentle jarring of the mold will settle the color
evenly and it should then be permitted to stand until of a good model-
ing consistency.

A GOOD MODELING CONSISTENCY for cement is deter-
mined by testing it with a tool or small pointed stick making a small
incision or trying a small section to see if the mixture holds its form.

If the cement as laid up on edge stays in position and does not have the tendency to fall or settle, it is then ready to model, as it will hold its form when built in relief.

PROMPT ACTION IS NECESSARY when the mixture is at this point and the tool should be promptly used scraping or sketching the subject by incised lines in the surface. Then parts of the cement are scraped from the low portions and placed on the parts to be in higher relief until the general rough forms are massed in. The smaller parts are then detailed in and the different parts finished just as one would in working with clay or modeling wax. If it is found that parts do not hold up, it is because under sections of the cement have not dried sufficiently and it will be necessary to wait until it hardens a little more.

THE FINISHED RESULT may be complete with the strokes of the tool or the modeling instrument showing over the entire surface.

If the technique is shown in this way, care should be taken that the strokes are pleasing in direction and not carelessly left. As the tile hardens it will be found that the surfaces or edges can be shaped, and even when the surface is almost hard, it can be slightly indented or carved to produce different textures and varying qualities.

GOOD MODELING TOOLS are those that are made from pear wood for sculptors use. Metal modeling tools also can be used. Good home-made modeling tools can be made from manicure sticks, pencils, dowel sticks or ordinary small hardwood pieces shaped with a knife. These pieces should be smoothed down very evenly with fine sandpaper and then rubbed with beeswax or paraffin to avoid any rough surfaces. Rough surfaces will cause the cement to stick to the tool. Experience will be a good guide to the worker in color cement for determining the best shape to make the modeling tool, as individual needs and ways of working will determine the best form for each person.

The Modeled Cement Tile
is commenced by incis-
ing the pattern and
building up the masses.

The Modeled Cement Tile
is finished by shaping
the parts and flattening
the background parts.

The Burnished Tile
is made by tracing
through paper upon
the half-hardened cement
with a dull point

The Scraped Tile is
the Burnished Tile
with the spaces scraped
between the lines to
secure a rough texture

Modeled and Carved Cement Tile Methods

CHAPTER 10
Color Cement
for Bowls and Vases

THE COLOR FOR BOWLS AND VASES is mixed the same as for the tiles and it will be found that the use of the muller to grind the color is necessary to secure a good mixture. The color should be of the right consistency for rotating inside of the molds, which can be best determined by a trial. It will fall off the sides if too thin and if it is too heavy it will fail to roll evenly.

TO PREPARE A VASE OR BOWL MOLD for color, the parts to come in contact with the color should be oiled after they have been immersed in water. The parts are then assembled and tied together. Corresponding marks or figures can be placed on the molds so that there can be no mistake in combining the correct sections. Such marks will avoid confusion, particularly where the mold may be composed of a number of sections. Molds for vases are not shellaced.

THE FIRST ROTATION is then made by taking a quantity of the color cement or slip, mixed only with neat cement of thick quality, and pouring it into the mouth of the mold into the bottom. A spoon may be used to place the color if the mouth of the mold is large enough. The color is then rotated by turning the mold gradually until the color covers all the inside of the walls and the surplus is poured out into a pan. If the color at first refuses to attach to the inside, a few slow revolutions of the mold will generally overcome the trouble as the oil is causing the separation and is overcome by a few turnings of the color.

THE SECOND ROTATION is accomplished in the same way that the first rotation was but not until the first layer has fairly set. The surplus from the first mixture may be used. It is placed or poured carefully in and the rotating done and the surplus again poured out, excepting that it is poured out from the opposite side so as to equalize the thickness of the neck section of the vase or bowl.

A THIRD ROTATION may be necessary if the bowl is a large surface or if the slip used has been very thin. After each rotation

the mold with its layer of inside color should be covered over with a damp cloth to prevent too rapid drying of the color. The second and third mixtures should be thinner than the first.

THE WALL MIXTURE is then rotated over the color stratas and is made of one part of cement and two parts sand. This mixture is necessary to give the bowl or vase strength and to make it water-proof. If neat cement alone is used the vase will check and crack in time, particularly if water is ever poured into it.

FOR SMALL VASES only one rotation of color is necessary and the second and third may be of cement and sand with a fourth finishing layer in color. This finish layer may be of any color desired within the range of color cements or of neat gray cement only.

THE FINISH ROTATION is the layer that will appear as the inside lining. This is made of color and neat cement and is rotated so as to cover the cement and sand mixture. This mixture may be placed in the mold after the vase or bowl has been removed from the mold, and this permits the possibility of carrying the inside color over the edge of the mouth and partly down the side as a decoration.

AFTER THE ROTATED COLORS HAVE DRIED, which generally takes from two to five days, the mold is carefully opened and the vase removed. Flaws or bubbles on the surface, if any, are cor-rected by scraping with a moistened knife parts of the neck that are not to remain and others filled in. The false neck or that portion that extends above the actual vase is now carefully trimmed away, leaving only the actual bowl or vase.

CARVING AND SCRAPING of the surface can be done while the surface is slightly soft which is soon after the bowl or vase has been removed from the mold. Glazed color may be placed into the spaces carved or scraped from the surface if the surface is moistened well with water, then adding neat cement over which the color is dripped following the instructions as given for the tiles.

TO HARDEN THE OBJECT molded it is immersed in a bucket of water and left for several days. If the surface has had color added to it after it has come from the mold, it cannot be immersed in water as the color would be floated off. It should have water poured on the inside and left to dry in a cool place.

TONING WASHES can be made of thin color and brushed onto the surface after the bowl has been well dampened. This will permeate the fine pores of the cement as well as gather into the crevices particularly of a carved or relief surface and if a contrasting color is used, it gives pleasing effects.

GLAZING BOWLS AND VASES is much more difficult than coloring tiles. The curved surface requires careful application. Prepare a quantity of desired color to be applied. Then spread it out in a pan or dish (a platter will do very well), revolve the bowl on the fingers so that the surface comes in contact with the color. The color will adhere and the bowl should be kept slowly revolving until the color sets. The bowl can then be filled with water and left to dry. If the bowl is kept in one position before the color is set, the moisture will cause it to run and mar the surface. After the first color has set an additional color can be dripped on at the top or other colors added into or onto this surface. Different effects will be possible, depending upon how soon the color is added to the first coating.

Dry color can be sprinkled onto the wet color and permitted to become absorbed, giving an interesting effect. The color may be applied with a brush or palette knife, and other ways of producing variations on the surface may be produced by experimenting.

A VASE FORM WITH MAJOLICA SURFACE will need to have the surface turned as it is worked upon. This can be done by revolving with the hand inside of it, or if too small turned on a right angle support, padded so that it will not injure the neck of the vase. The vase may have one end supported on something to keep the

worked part from coming in contact with the surface. After a part has been filled in, it should be left to set for a minute before turning the surface, otherwise the color will drop out.

After the color is all in position, stand the vase upright and with a funnel fill with water and let it harden for several days. The water will supply the color surface with moisture preventing it from drying too rapidly.

Any cement surface (tile or vase) before it is very hard can have motifs scraped into it so that the design is a series of shallow openings in the surface. The color cement can then be dripped into these openings similar to majolica work and completed in the same way.

A vase with a plain surface can be made exceedingly attractive by adding a few simple motifs well chosen and placed on the surface in this way.

FOR SLIP PAINTING tile or pottery surface, various colors to be used should be mixed and ground on glass or marble with palette or putty knife until thoroughly smooth. The colors should be placed in order on a glass or enamel palette. Other hues may be produced by the mixture of these colors or lightened by adding a white cement. A small brush is used to apply the color. The surface to which they are being applied should always be damp and the complete surface to be colored should be done at one sitting. The tile or vase is then placed in water as previously explained.

It is best that the color be thin rather than thick, and avoid going over a surface a second time. A second stroke will destroy the lustre which will otherwise remain on the surface.

A VASE OR BOWL FORM to be used for slip-painted color will have to set a few minutes to prevent the color running when the bowl is turned for new working surface. The bowl or vase is carefully filled with water and left to set for several days, care being taken that no water drops onto the slip painting. The object worked upon must be set in the shade to dry, where nothing will come in contact with it.

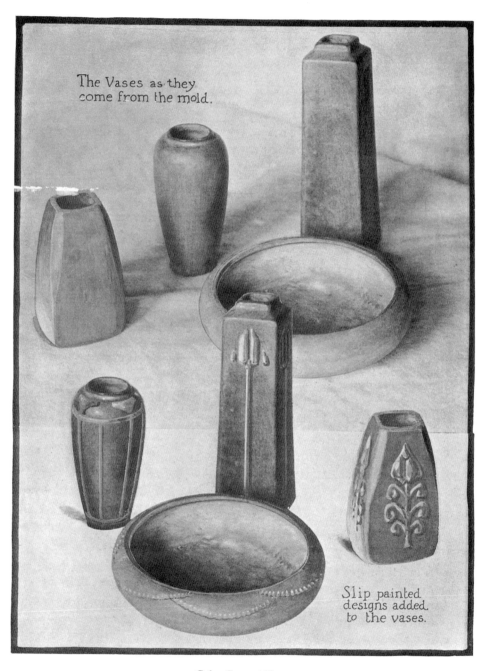

The Vases as they come from the mold.

Slip painted designs added to the vases.

Color Cement Vases

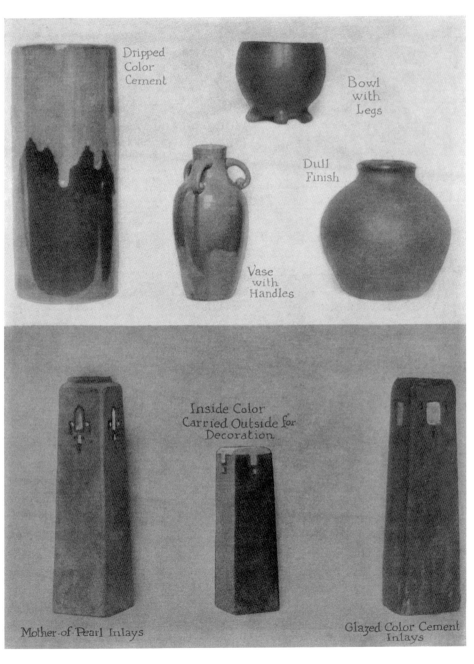

Dripped
Color
Cement

Bowl
with
Legs

Dull
Finish

Vase
with
Handles

Inside Color
Carried Outside for
Decoration

Mother-of-Pearl Inlays

Glazed Color Cement
Inlays

Color Cement Vases

CHAPTER 11

Glass Mosaic Tiles

FRAGMENTS OF STAINED GLASS can be secured from almost any stained glass works without cost, as much of the odds and ends of glass are thrown away. These fragments can be used in making Glass Mosaic Tiles, and used correctly will produce charming and interesting results.

Mother-of-pearl or abalone flakes can also be used as small bits here and there in designs and will be found to give an additional rich effect.

Semi-precious stones or glass beads can be used in many ways such as handles and tops or as rests for tea tiles, etc. The beads can be sunk into the cement until the hole through the bead is concealed.

TO MAKE A GLASS MOSAIC TILE there are four steps as follows:

 1st. Making and tracing the design.
 2nd. Cutting the glass.
 3rd. Pouring the cement backing.
 4th. Releasing the tiles and finishing.

FIRST STEP: MAKING AND TRACING THE DESIGN. To make a design for glass mosaic, plan a very simple design for the first problem. A few squares joined by simple bars, composed in a simple pleasing arrangement will be hard enough. Objects such as flowers, birds, trees, etc., must be planned in simple forms. Remember that each piece is to be cut from glass and intricate outlines, etc., must be abbreviated. Decide what direction of line will tell the most in the shortest length. It will be found that designing for glass mosaics or for stained glass is one of the best influences for recording large masses, for producing the maximum amount of subject with the minimum means of line.

After the design has been drawn out on paper it should be colored to correspond with the stained glass fragments that have been secured. Right here it may be well to state that the glass mosaic

need not be entirely covered with glass sections. Much of the background may be cement and the colored portions (stained glass and mother-of-pearl) may be only a certain portion or design running across the tile surface.

After the design has been colored, make a firm tracing from it and place the tracing upside down on the table and a glass over this large enough to cover it fully. The stained glass sections are assembled upon this glass as they are cut.

SECOND STEP: CUTTING THE GLASS. A small glass cutter with a wheel can be purchased at any hardware store and with a little practice glass can be easily cut. Once the wheel is placed upon the glass it should be pressed slightly so that it grips the surface. Then draw the cutter firmly toward you without changing the angle of the handle and without turning the handle to one side or another. A few taps with the tip of the handle on the under side of the glass and a "bending and pulling apart" motion of the glass with the fingers will cause it to come apart after the cutting. Some glass cuts much easier than others and a good cut with the cutter will cause it to come apart upon the slightest bending in the fingers. Do not run the cutter wheel over a cut line in the glass a second time, as it will injure the wheel. Practice cutting clear glass as well as stained glass. The glass cutter should be placed with the wheel in turpentine to preserve the cutting edge.

To cut the glass in the right shape use either of the following methods: Trace the design upon stiff paper and number each section of the design to correspond with numbers on the original sketch. Cut these sections apart and use them as patterns to lay on the glass. The glass cutter is then run around the edge of the pattern in cutting the glass. The second method is to trace the sections to be cut directly onto the glass. If carbon paper is used, the line will be definite enough to follow.

SMALL SECTIONS OF GLASS can be better separated after the glass cutter has been used if small pliers or dull nippers are used to grip the glass. Hold the largest piece of glass firmly between the fingers and with the nippers grip the glass close up to the line of division and with a quick downward turn of the nippers it will divide the glass along the line produced by the cutter.

The sections of glass when all cut may be trimmed to truer forms by using a corborundum stone or file.

AFTER THE GLASS HAS BEEN CUT, place a tracing upside down on the table and a glass over the tracing. The tracing on the underside of the paper should be visible through the glass, and of course is reverse in position. Take each piece of glass and touch the right side with glue and place it onto the glass over its location defined by the tracing. Assemble all the glass in this way, all the pieces being glued face downward onto the glass. Mother-of-pearl, metals, etc., can be assembled the same way, and the fact that they are thinner than the glass need make no difference as their surfaces all resting upon the glass will result in their being all the same level on the completed tile.

THIRD STEP: POURING THE CEMENT. After the glass has been glued and left remaining for several hours (to permit the glue to dry) the retaining bars are placed on the glass, at the proper distance from the cut sections and cement is then poured into and over the glass mosaics until the required thickness of tile is secured. This mixture may be color cement or the neat Portland cement, care being taken to pour it in slowly from the center to avoid formation of bubbles.

FOURTH STEP: FINISHING THE TILE. When the tile has set for several days it may be removed and an incised line made around the edge of each glass mosaic. Place the tile in water to

harden for several days. Remove and let dry, then give the entire surface a gasoline wash of gray or other color. A slight polishing of the surface will finish the tile. It will be found that the moisture has softened the glue so that the whole tile releases from the glass surface. The cement should be rubbed off of any of the glass parts if it has encroached until the entire edges of the glass mosaics are visible. This should be done before the tile is placed in the water to harden.

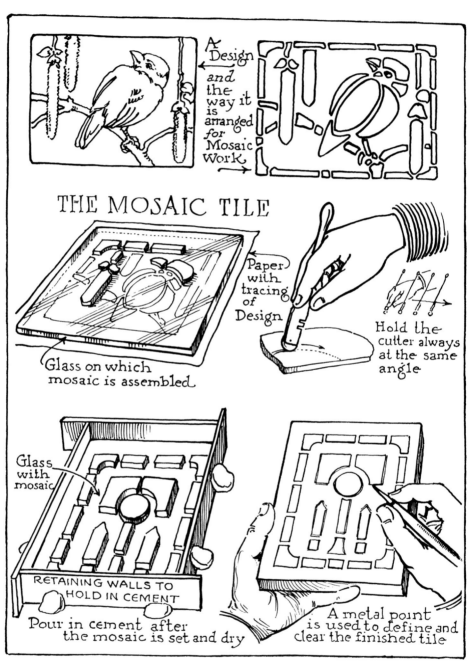

A Design and the way it is arranged for Mosaic Work →

THE MOSAIC TILE

Glass on which mosaic is assembled.

Paper with tracing of Design

Hold the cutter always at the same angle

Glass with mosaic

RETAINING WALLS TO HOLD IN CEMENT

Pour in cement after the mosaic is set and dry

A metal point is used to define and clear the finished tile

Mosaic Tile Method

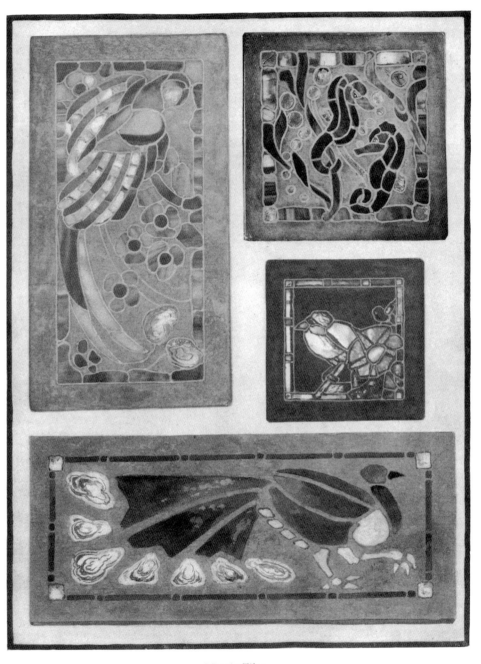

Mosaic Tiles

One hundred and seventeen

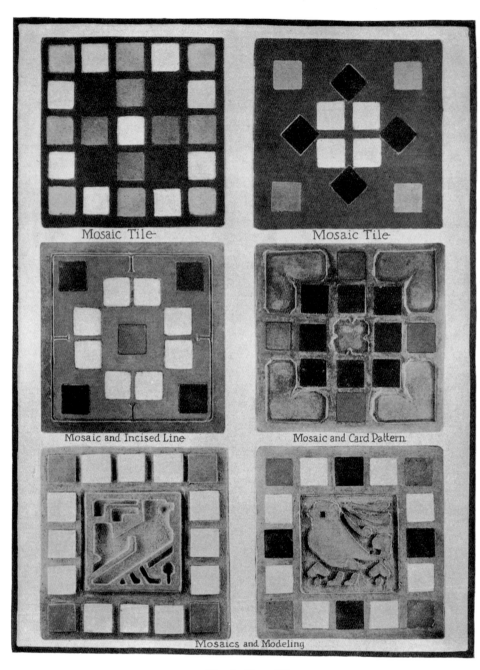

Mosaic Tile

Mosaic Tile

Mosaic and Incised Line

Mosaic and Card Pattern

Mosaics and Modeling

Mosaic Stone Tiles

CHAPTER 12
Flower Boxes and
Other Straight Forms

THERE ARE THREE WAYS TO PRODUCE FLOWER BOXES in color cement and the methods equally apply to other straight-sided objects that are to be hollow or act as containers.

MOLDS MADE FOR STRAIGHT-SIDED OBJECTS have the advantage of permitting the joints of the molds to come on the corners or junctures of the straight sides; thereby making the entire elimination of any joints remaining on the object (from where the molds come together) an easy matter of removal.

ONE OF THE WAYS TO PROCEED IN THE MAKING OF A FLOWER BOX is as follows: Take any ordinary good proportioned small wooden box, or block of wood of the right shape, and place a thin layer of modeling wax over the surface until it is smooth and evenly coated. Model the design desired on the four sides, avoiding, as has been before cautioned, having undercut or overhanging portions.

THE DESIGN MAY BE SECURED WITHOUT MODELING by taking the box and covering the sides with cut cardboard designs, the cut sections producing the motifs or the spaces between the cut and applied portions being the motifs. In either case the cut sides of the portions applied should slant so that the widest portion of any opening formed where two applied pieces come together will be widest at the top. The reason for this is to prevent locking of the plaster which will be poured over the surfaces to produce the molds.

IF THE CARDBOARD IS USED FOR THE DESIGN after the glue is dry, the entire surfaces of the portions to come in contact with the plaster is given two coats of shellac, the second coat to be given after the first coat is dry. The shellac should be permitted to dry well.

TO MAKE THE MOLDS the box with the design is turned up-side-down and a mold is made of the bottom first. This is done by

surrounding the four sides with wooden retaining walls so that the sides extend at least an inch above the edges. Into the space formed by the four projecting walls, plaster is poured and permitted to dry. This will result in a slab of plaster to reproduce the bottom of the flower box in the final cement casting. If legs or irregular portions are on the bottom, the mold should include these portions.

As soon as this bottom section is hard, the keys are bored into it and one of the sides is next molded. When molding the sides, turn the model so that the plaster is poured onto the sides and not so that it is poured alongside the surface. This is done by turning each side to be molded so that it is horizontal or flat.

WHEN ALL THE MOLDS ARE MADE and dried they are ready for casting the cement box. They should be placed in water until all parts have absorbed moisture. Next they are oiled well and assembled. If more than one color is to be used, the molds for those sides to have color should have the color cement placed on the molds while the surfaces are flat. When this color has set sufficiently to permit the sides to be placed upright, without the color running, the sides should be assembled with the bottom mold and the whole set tied together ready for the pouring of the cement.

THE FIRST MIXTURE OF CEMENT should be a thick mixture, just as thick as will run easily when the mold is rotated. The first mixture of cement should be of neat cement and may have color mixed with it. It is poured into the mold or placed in with a spoon, and the mold is rotated slowly until the mixture has covered all the inside surfaces. The surplus, if any remains, is poured out from one of the corners.

THE SECOND MIXTURE OF CEMENT should be poured in after the first layer has set. This usually takes from an hour to half a day depending on climatic conditions. The second mixture should be of sand and cement and of a thinner mixture than the first. This

is necessary as the first layer will absorb moisture very rapidly from the second layer and therefore it should be very thin.

THE LAST LAYER OR MIXTURE should have color in it also and is added in the same manner as the second mixture, after the previous layer has set. This is the finishing layer and the color should be arranged to be in harmony with the outside color. A harmonious color will be one that is a lighter value of the outside color or it may be color that is complementary to the outside color.

THERE ARE TWO IMPORTANT THINGS TO REMEMBER in making pottery or boxes where the molds are rotated. One is that the mold to be rotated should not be shellaced. The reason for this is that the plaster molds must absorb some water from the cement mixture to produce the thin lining or inside coating. The second thing to remember is to pour the surplus mixture in the second rotation from the side opposite that the first surplus mixture was poured. As the lining is inclined to be thicker where the pouring out occurs, using an opposite side for the second pouring out will equalize the lining of color.

THE SECOND METHOD TO PRODUCE A FLOWER BOX is by spreading the color in the mold with a knife, pressing it up against the sides with a palette knife or small trowel. This is possible because the opening is large enough to permit seeing the sides. Where the opening is small such as that in a vase or jar with tapering sides it cannot be done this way and the method of rotation must be relied upon.

WHEN SPREADING THE COLOR CEMENT or lining, the mold should be turned so that as the mixture is placed and spread a flat surface is being worked upon. This makes it easier to work and insures the cement adhering to the mold. After the sides are fully covered, a thin mixture may be poured into the bottom and this whole mixture (the bottom and walls) permitted to harden.

IF DRAIN HOLES ARE NEEDED in the bottom of the flower box, two cylinders of clay or modeling wax may be placed upright in the bottom of the mold. These cylinders should be long enough to protrude above the bottom layer of cement that is poured in, and after the cement layer has hardened, they may be removed. This is preferable to endeavoring to drill the holes out of the bottom after the box is removed from the mold which might result in breaking the entire box.

AFTER THE BOX IS ENTIRELY DRY it may be given a gasoline color wash or rubbed with a thin color cement wash and after the color has become partly dry, the surplus rubbed off with a cloth. A wax rub given with a soft cloth and floor wax afterwards will smoothen up the entire surface producing a velvety surface.

THE THIRD WAY TO PRODUCE A BOX in color cement is by pouring, and the method is as follows: When making the molds instead of making the parts as usual, make a mold part for the top instead of the bottom, as the pouring mold is made upside down.

When the four sides and top portion of mold are ready, they are assembled and the metal inside mold is placed inside of the plaster mold.

THE METAL INSIDE MOLD is a metal pattern which when folded together represents the inside space of the box. Within this metal pattern or box, strips of wood or plaster should be placed to keep the metal or tin form in shape when the pouring of the cement commences. A good way to secure a perfect fitting brace inside of the metal form is shown in the working plate accompanying this chapter.

When this metal box with enclosed bars is placed in the right position within the plaster mold, the cement mixture is then poured into the spaces between the outside mold and the metal box until the space is filled. Then the cement pouring is continued until the top

of the metal box is covered adding enough more to form the bottom. It will be thus seen that the metal box must be planned low enough so as to permit of a bottom space.

TO FINISH THE BOX, it is turned over after the cement has sufficiently hardened and the plaster, or wooden bar, is removed. The sides of the metal box are folded inward and the entire box removed. This will leave the inside of the box free for the smoothing or scraping of faults or filling in of bubble holes which can easily be accomplished before the cement has entirely hardened. The outside portion of the plaster mold is then removed and the flower box appears complete except for the surface coloring or finishing as may be desired.

OTHER SQUARE-SIDED OBJECTS may be similarly treated, in some instances the shapes or proportions requiring different hand-ling. For instance, a very long narrow box could not be easily pro-duced by rotating and should be made by the spreading or pouring method. Large surfaces or very long surfaces should be reinforced by the placing of wire cloth in the walls when the cement is poured in.

TAMPING OR PRESSING OF CEMENT is done by using cement and sand of a consistency like wet sand. This is placed into the mold and pressed firmly with a blunt stick, and a mallet can be used to tap these wooden chisels so as to press the cement well into the apertures. This results in a very firm surface and is particularly good for large boxes and containers. Care should be taken that the molds are firmly fastened together and the molds should be watched occasionally while the tamping is taking place to see that they do not spread.

TILES, STAINED GLASS AND MOSAICS may be included in the decoration of flower boxes. They should be glued firmly into position on the molds or boards forming the mold for the box. After a day or two drying the molds are assembled and the cement is poured

in the usual way. The moisture in the cement will be found to soften the glue so that on removal of the molds the tiles, glass or mosaics will remain with the cement.

TO INCLUDE HANGING CHAINS, RINGS OR HOOKS in a cement box, the mold should be arranged so as to accommodate the chain or metal through it. The part or opening through which the metal passes is filled with clay or wax to avoid the running out of the cement. The molds can be held up from the table surface by a few blocks of wood or worked upon after being placed on a trestle.

COVERS TO BOXES can be made in the same manner as boxes. A single flat lid may have fewer molded parts but should have enough to permit easy release of the cement.

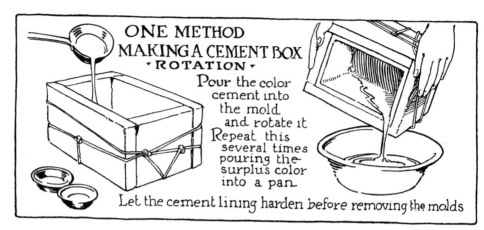

ONE METHOD
MAKING A CEMENT BOX
· ROTATION ·

Pour the color cement into the mold and rotate it. Repeat this several times pouring the surplus color into a pan.

Let the cement lining harden before removing the molds

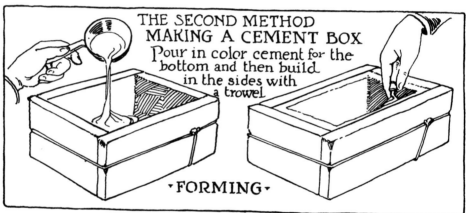

THE SECOND METHOD
MAKING A CEMENT BOX

Pour in color cement for the bottom and then build in the sides with a trowel

· FORMING ·

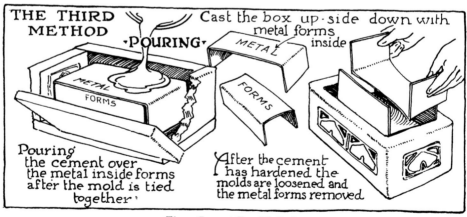

THE THIRD METHOD
· POURING ·

Cast the box up-side down with metal forms inside

METAL FORMS

Pouring the cement over the metal inside forms after the mold is tied together.

After the cement has hardened the molds are loosened and the metal forms removed

Three Cement Box Methods

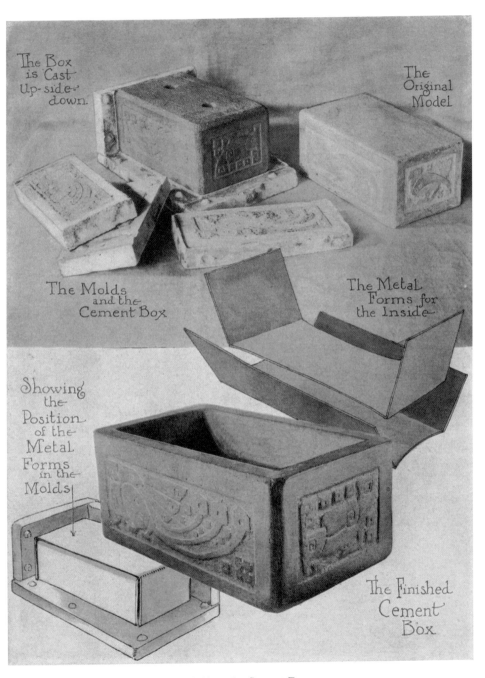

The Box
is Cast
Up-side-
down.

The
Original
Model

The Molds
and the
Cement Box

The Metal
Forms for
the Inside

Showing
the
Position
of the
Metal
Forms
in the
Molds

The Finished
Cement
Box

The Making of a Cement Box

CHAPTER 13
Color Cement for the Garden

ARTISTIC GARDEN WORK can be enhanced by the use of color cement. While ordinary cement and concrete construction has been much used, there are still greater possibilities with the use of color cement. The use of color in the open permits the use of bright colors, in key with the flowers and foliage; and with color cement the formal or Italian garden scheme or the informal or Japanese manner of garden arrangement is delightfully possible. Pottery, garden furniture, fountains, walls, chimneys, pools and walks are a few of the possibilities with color cement.

LARGE GARDEN POTTERY is produced by the same principles as vases and bowls, but as the proportions are much larger, the methods of working are different.

Where a large jardinière is to be made, the form should first be built up from clay and be formed upside down. Bricks or any other solid material may be used for the main body of this form, and the clay built over it as it will not then require so much clay. If a long nail or rod or strong stick is placed in the center of this mass, it can serve the purpose as an axis to a templet which will form the contour of the jardinière when moved around in a circular direction. The metal must be good and heavy and sometimes it is necessary to reinforce the templet with wood.

After the clay form is built, cases are made in several sections from the plaster the same as for small forms; and cement and concrete used in large quantities after the same method as for small forms.

Large dish-pans, pails, etc., may be used for securing the inside form for garden pottery. Oil the outside and bottom of the pail or pan used and place it upside down on a table. If only a certain part of the bottom is wanted, clay should be built up around it, so that only the part wanted is exposed. With a strip of tin or linoleum for a moulding case surround the inverted utensil and then pour the concrete around and over it.

TO FORM THE GARDEN POTTERY more accurately on the outside, take it out from the mold in two or three days and trim with a knife to the desired form (in winter let the form stay in the mold four or five days). If extensions or additions are wanted the vase, bowl or jardinière, should be soaked in water for an hour or two and the form made from tin or other material placed in position and the cement poured into the forms.

To secure smaller parts independent from the larger parts such as fishes or cup forms for fountains, etc., the smaller part should be made separate from the large form but a pin or extension should be arranged so that it will fit into a groove on the larger form. This can then be built together by the addition of a little cement.

GARDEN SEATS. The seat and ends can be made by using wooden forms which can be released easily. Openings in the ends can be arranged by either the use of wooden blocks or clay bars placed in the right location. These blocks or bars should be taken out after the cement has dried three or four days. A few nails in the blocks will make it easier to lift them out.

Tiles made as previously explained can be inserted into the ends by scraping an opening to accommodate them while the cement is still soft. A little cement poured into the back and around the edge will fasten the two together.

GARDEN FOUNTAINS. The bowl for fountains should be made independent of the base or pedestal, but arranged so that the two groove together. This can be planned by taking a clay impression or a plaster casting from the surface. For instance, in making a bowl to rest on a pedestal, the bottom of the bowl should have keys or projections planned. Now supposing the bowl is finished, a pedestal should have depressions in it to correspond with the projections on the bottom of the bowl. To secure these the bowl itself or an equivalent surface in clay or plaster must be made to combine

with the other parts of the molding case when the pedestal is made. These keys or grooves can be scraped out of the pedestal top when soft if care is taken to secure the right location. By resting the bowl upon the top a slight indentation will be made so that the indentation can be increased to the proper depth to secure complete "register" between the two parts.

When making plaster mold cases for large pieces, burlap, coarse cloth, etc., should be dipped rapidly into the plaster and used to build up the molding case. This produces greater strength in the plaster case.

A DESIGN UNIT used on large pottery or as a border to any large surface can be planned and modeled in modeling wax. From this model a mold is made in plaster. The clay can be pressed into this mold, lifted out and placed upon the surface to receive it. A slight pressure and joining of the edges will make it conform to the surface.

TO REINFORCE LARGE PIECES, wire, iron rods, wire mesh, or any such material will serve the purpose. Any narrow junction point or narrow part connecting two large parts should be reinforced.

PIPE CONNECTIONS FOR WATER, GAS, OR ELECTRIC WIRES must be planned for often in garden furniture. A round wooden rod with a smooth surface and oiled, having a larger diameter than the pipe to be used should be used in the mold. This is then withdrawn to make room for the iron pipe. A pipe can be used in place of the wooden rod, but of course it is then held firmly in place, becoming part of the mass. All pipe should be threaded for proper connections, and it is very advisable that you confer with a plumber or electrician so that no mistakes will be made.

Straight-sided forms can be made from tiles as follows: Take four tiles, soaked in water, afterwards imbed them on edge upside down in a layer of clay. They should be placed vertical and at right

angles to each other. It is also better that the corners do not meet.
Within these four tiles a clay cube is placed leaving a certain space all
around for the wall. The cube should also be lower than the height
of the tile to allow for the bottom as the box is made upside down.
With clay or cardboard stop the corners and then pour in cement to
the top of the tiles. Let harden for a few days; then remove clay,
smooth up corners, and set in water to harden. Fern dishes, plant
holders, etc., can be made in this way with as many sides as desired.
The accompanying chart further explains this problem.

GARDEN WALKS can be made with large irregular cement
slabs or stones formed with concrete. This will produce all the
beauty that comes from natural flagstones and enables anyone to
secure the effect even when flagstones are not securable. Flat tile or
irregular tile can be produced as a finish surface to the concrete base
underneath, the whole being one solid mass, eliminating much of the
breaking up and loosening that comes when separate tiles are placed in
a surface.

COLOR CEMENT FLAGSTONES are made as follows: First
prepare a solid earth under-foundation. To do this the surface is
pressed with an iron roller or tamped with an iron tamper or heavy
wooden block. If the surface has been previously walked upon for
some time, it will be good and solid. On this surface indicate by
scraping with a stick or trowel the shapes of the flagstones desired,
and scrape the earth out of these areas to a depth of one to two inches.
This surface is then sprayed with water until it remains damp and is
ready for placing the concrete mixture.

THE CONCRETE PROPORTIONS should be one part cement
to two parts or three parts gravel. These parts are mixed well to-
gether dry and then water is added while it is mixed again. The best
way to add the water is to have one person spray the water from a hose

while a second person uses a hoe to mix the wet portions and expose the dry sections.

A MIXING TRAY can be made from wood and should hold water fairly well as it is important that there be no leaks while the mixing is proceeding as the leaking water may carry off much of the cement. After a box has been used several times, the cracks and crevices will become filled and the mixing tray will become more water-proof.

WHEN THE CONCRETE IS THOROUGHLY MIXED a portion is then taken and placed in one of the scraped areas and shaped with a trowel. The sides should be left thick and preferably tapering slightly upward. This prevents breaking edges later when in use such as occurs if the edges overhang.

THE TOP LAYER should be of colored cement and may be a very thin layer, but in order to be durable it should be composed of one-half part of cement and one-half part of gravel or sand. This is mixed with color sufficiently to tint it, but the color should not be too great in quantity for it will weaken the strength of the mixture.

THE COLORS FOR THE CEMENT FLAGSTONES is dry color and may be Venetian red, yellow, ochre, Indian red, lamp black, burnt umber, or burnt sienna. This mineral color should be mixed in well with the dry concrete before water is added. Colors can be changed by mixing one color into another. For instance, the red can be made less intense by the addition of burnt umber or with the addition of a little lamp black. When adding another color to a cement mixture to which water has been combined, do not add the color dry but mix it with water first until it is a paste before mixing it into the first mixture.

TO FINISH THE FLAGSTONES the color mixture is spread over the first portion placed in the scraped area and spread with the trowel until it covers all the surface of the first pouring. When this

strata has partly set, it can be surfaced with trowel marks or a few twigs or weeds can be held in the hand and whipped over the cement surface, producing a roughened texture. The stone should then be covered so as to protect it from being walked upon and after the second day it should be sprayed with water to help its hardening process while drying. Do not permit the sun to prematurely dry the stones as the slower a cement dries the more durable it will be.

BRIDGE WORK FOR THE GARDEN can be constructed with cement, and the use of color combined with cement will enhance the project if used reservedly and in good arrangement. Iron posts or supports can be used as under parts of the bridge or a temporary support of wood can be used. A wooden barrel has been used successfully to form the opening under a cement garden bridge, the staves being knocked in to remove the barrel after the bridge was completed. Stones and tree limbs can be combined with the cement bridge toward creating informal effects. The Japanese garden is delightfully arranged with many surprise effects of stone work and pools, all of which can be duplicated with cement.

NATURAL EFFECTS can be secured with the proper use of cement and the possibilities are only limited by the time and interest of the worker. It must be remembered that cement and concrete is a process of creating stone and the stones can be formed in pleasing shapes and finishes and colors according to the wish of the worker. There is great opportunity for the worker with color cement to create garden ideas either for pleasure or for remuneration and any enthusiastic worker can plan and direct such work for neighboring needs or for those who are always anxious for the different but pleasing garden creation.

A TILE EFFECT for walks or courts in regular pattern can be made by pouring a color layer over a concrete solid layer. Previous to the pouring thin strips of wood are placed so as to divide the space

into the tile shapes. These strips are afterwards taken out and the tile edges scraped round, and the spaces where the wood was placed is then filled with gray cement. This produces at considerable less expense the same result as the inlaid tile surface.

THE DECORATED GARDEN TILE is where the color cement is poured onto the square or rectangular concrete stones and while it is semi-moist other color is dripped on or stroked into the surface with a brush, forming a design motif. These motifs may appear at regular or irregular intervals depending upon the pattern arrangement of the stones, and can be of flowers, quaint birds or animals, preferably in abstract arrangements.

CHIMNEY STONES or flat stones for surfacing fireplaces or stone walls can be made by pouring out the concrete mixture to which color has been added. These should be poured onto a fairly hard ground surface which has been previously watered. The stones can be of varying shapes and sizes and with varying tints of colors. Gray cement alone will give a good color to which may be added those made of Venetian red, Indian red, and lamp black or yellow ochre.

When dry they should be immersed in water and then added to the brick undersurface of the chimney or mantel by using a mortar made of a mixture of lime and clean sand with water. To this add one-fourth to one-sixth part Portland cement. The lime should be prepared previously to combining with the sand by adding water to it, letting it remain for a half day to two days in order that it will become slackened. Lime gives adhesiveness to the plaster, and the brick surface to which the stones are placed should be moistened with water before adding the plaster layer into which the color cement stones are to be pressed.

Many other fascinating uses of color cement will develop into successful applications in the hands of the craftsman who is interested in beautifying the garden.

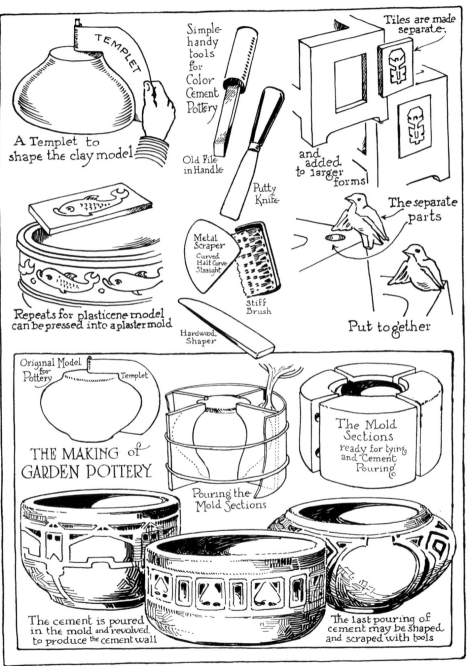

Helps in Cement Garden Pottery

One hundred and thirty-seven

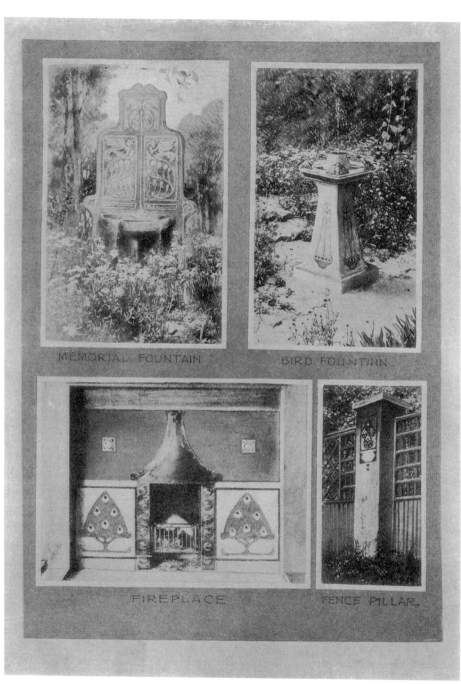

MEMORIAL FOUNTAIN

BIRD FOUNTAIN

FIREPLACE

FENCE PILLAR

Application of Cement Tiles to Architectural Use

Color Cement Flagstones Used for a Bridge, Garden Pathway, and Entrance.

Color Cement Used for Chimney Stones and Flagstones

CHAPTER 14

The Making
of Candlesticks and
Book Supports

TO MAKE A CANDLESTICK WITH STRAIGHT SIDES the molds should be made in sections, the divisions occurring where the corners come. This results in the object coming from the mold with the mold lines where they can be easily removed.

THE MOLD FOR A CIRCULAR CANDLESTICK or round base can be made in three divisions similar to the making of a mold for a round vase. The mold lines occurring on the surface can be obliterated as soon as the object is removed from the mold.

A MOLD FOR A CANDLESTICK DIFFERS FROM A VASE MOLD in that it is made upside down. As a candlestick is made solid instead of hollow like a vase, the mold is filled from the bottom, the open part to hold the candle being a projecting section into the space of the mold into which the cement is poured.

TO MAKE THE MOLD SECTIONS the small section to reproduce the hole for the candlestick is first made. The original model, made either from clay or modeling wax, is placed upright and a strip of oiled cardboard or metal fastened around the top and plaster poured into the candlestick hole and up above the top to the level of the cardboard or metal which should extend at least an inch above the top of the candlestick.

AFTER THE MOLD FOR THE TOP IS MADE each side should have a key space bored into it and then the mold is placed back into the model, the exposed portions of the plaster are oiled and the side section (round or straight section) is next made, leaving the bottom open. The completed parts of the mold are assembled and dried before using them for the cement cast.

TO POUR THE CANDLESTICK CAST, assemble the molds after they have been immersed in water and oiled and after tying them firmly together turn them upside down and pour the cement into the opening. If a color is to be used, the color should be poured in and

the mold rotated until the color covers the inner surface. Surplus color should be mixed and kept to use later in completing the bottom. After the lining has set, a mixture of sand and coarse cement should be poured into it and permitted to settle. Jarring or tapping the mold will help the cement to settle. If it settles, more cement should be poured in. After it has settled, the color surplus similar to the surface lining is poured on to finish the bottom.

WHEN THE MOLD IS OPENED the sides are opened first and the small mold section forming the candlestick hole is carefully twisted out. If when making this part of the mold, a T shape wire has been inserted it will strengthen the mold.

TO MAKE THE BOOK SUPPORT, a model should first be designed and modeled in clay or modeling wax. This design must be considered from its practicability and the structural design therefore must be carefully planned. The base on the book support should be heavy enough to overbalance the upright portion so as to prevent the book support from falling over. The upright portion may be of any simple shape and enriched in any of the methods previously described for the decorating of tiles.

A WOODEN BASE OR BACK FOR THE MODEL may be used on which to place the modeling wax. A thin layer of the modeling wax may be placed over the entire surface, and variations to the shape also can be made with the modeling wax. A panel of plaster or a tile design can be incorporated into the model instead of modeling. This method has been often used and found to give good results.

GESSO OR RELIEFO MODELED PANELS CAN BE USED for book support designs by attaching them to the surface of the model. If the gesso or reliefo is first shellaced it will be found to be an excellent material with which to produce modeled designs for color cement handicraft.

AFTER THE MODEL IS COMPLETED the first part of the mold to be made should be the portion with the design. The triangular shape of the design and base portion should be placed in position and supported so that a single pouring of plaster will produce a mold of the design and the upper surface of the base. Different shaped bases or irregular shaped bases will require individual consideration when planning the molds. The main thing to consider is that the parts of the molds must be made so that the cast will release easily from the molds.

THE SIDES OF THE BOOK SUPPORT are next made, casting the sides while the first piece cast is kept in close position over the model and drilling keys in the sides to produce locking holds in the mold sections. The top of the model is also cast, the bottom being the only portion not made, as the book support like the candle is cast upside down.

PRECEDING THE POURING OF CEMENT the mold sections are soaked in water, taken out and oiled, assembled and put closely together, and tied firmly in position. The colored cement slip is then poured in, the mold is rotated and the concrete or cement filler is poured in and permitted to settle. The bottom or last layer is then poured on in the same color as that used for the lining.

TO INSURE QUICK ASSEMBLY OF MOLD PARTS when working, the molds should be marked with corresponding numbers so that the correct parts can be put together rapidly.

TO FINISH THE BOOK SUPPORT it is removed from the mold, trimmed as needed, placed in water to harden for several days, taken out and permitted to dry slowly and then brushed well and waxed. A thin coating of shellac may precede the wax. Two sets of molds for book supports will enable two book supports to be made at one time and in this way the color of both can be made to match each other.

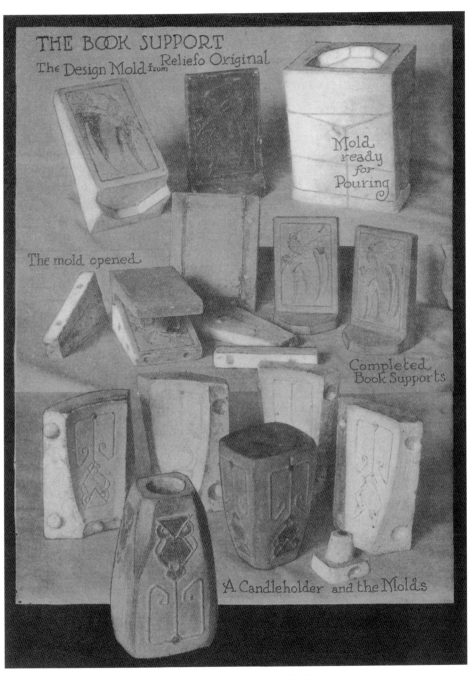

Book Support and Candlestick Molds

CHAPTER 15
Color Cement for
Interior Decoration

PRACTICAL USE FOR COLOR CEMENT inside the home is one of the greatest possibilities with color cement as a handicraft. It enables the home builder, the art student, or the busy housewife who has some idea of decoration, to plan and execute durable tiles or panels for the floor, walls or fireplaces, and to execute them with but little space and equipment.

TO MAKE TILES FOR THE FLOOR, the tiles should be made in flat surfaces and without relief parts that will project so as to become worn from being walked upon. For floor surfaces pressed tiles are better than poured tiles. Manufacturers of common cement tiles for architectural purposes produce them in presses with several tons pressure. The craftsman can secure very good pressed effects by using backing cement that has very little moisture in it and tapping it in well, using a block of wood and a mallet. The retaining sides of the mold should be of wood or of some durable material that will withstand the pressure, and hold together firmly.

POURED TILES FOR FLOOR USE made from a strong mixture of sand and cement and with a small proportion of color will be found to be durable. One or two coatings of shellac and a covering of floor wax will further increase the durability of the wearing surface.

PLAIN TILES FOR FLOOR USE can be used with decorated tile and various interesting patterns can be made (a few of which are shown) by interspersing the tile in different arrangements. A glazed tile can be made and used as a variation in combination with mat finish or dull finish tiles. Several small tiles may be used to fill a space and produce patterns in contrast to larger tiles. It will be found that with a little design arrangement many interesting floor arrangements can be made with tiles.

WHERE A LARGE NUMBER OF TILES ARE TO BE MADE several molds in plaster-of-Paris should be made and a large quantity of color mixed at once, and the first color placed in each tile

consecutively and then the next color, until all the colors have been placed in the six, eight, ten or whatever number of molds is being made at the same operation. After the color has set, the backing mixture of concrete is made and poured into all the tiles.

A TEMPLET PATTERN MOLD for floor tiles is made by cutting templets from either cardboard or linoleum with slightly tapering sides and gluing these into position to produce the design. The templets should duplicate the portions of a design and the design should be the first step in the problem to be solved.

THE DESIGN FOR TEMPLET PATTERNS should be simple in form and division. Geometric patterns and straight line forms are the best for use. Good divisions of squares and rectangles and these divisions changed slightly to floral or leaf shapes should be as far as any elaboration should go.

AFTER THE TEMPLET PATTERN IS CUT it is assembled and glued into position on another card or glass surface and given two coats of shellac. It is then placed within the retaining bars and a cast is made in plaster. This cast in plaster is afterwards shellaced and becomes the mold for casting the cement tile.

TO CAST THE CEMENT TILE the colors selected from parts of the design are first mixed and placed into the mold. After the colors have been all placed and permitted to harden, they are backed with a mixture of neat cement and color which is next backed up with a concrete mixture and then permitted to dry for three days. After being hardened in water for several days after its removal from the mold, it is then ready to be cemented in position for floor use.

THE BACK FINISH OF WALL TILES should have countersunk spaces to permit a good grip or hold of the mortar that will be used to hold the tile in position. These grip holds can be made by cutting four small rectangular sections of cardboard and pressing them

closely together into the back of the tile after the last layer of cement has been poured. After the cement has dried thoroughly and the tile is ready to be removed from its mold, these cards can be easily removed.

TO USE WALL TILES they should always be immersed in water before the mortar is applied. This prevents the moisture being absorbed out of the mortar by a dry tile and assures better sticking of the tile to a perpendicular surface.

TO MAKE GOOD MORTAR, building lime is placed in a mixing box or bucket and water poured over it. Next day it can be taken and mixed with sand until a rich, thick plaster results. To this add one-quarter or one-eighth part of Portland cement to make it strong.

TO APPLY TILES TO AN UPRIGHT SURFACE, spray the brick or rock surface with water. This can be done with a whisk broom or a large brush. A cloth immersed into water and dabbed onto the surface will serve very well. The tile which has been placed in a bucket of water to absorb moisture is then covered with mortar on the reverse side. The surface of the wall or fire mantel to receive the tile is also covered with a layer of mortar and the tile is pressed into the mortar, causing the two layers (the one on the tile and the one on the wall) to adhere to each other.

TO CONNECT TILES ONTO AN OLD CEMENT SURFACE the following method should be used: Clean the old cement surface well with a brush and water, removing the dirt and dust. Sprinkle a thin layer of neat cement onto this surface while the floor is still moist. Work this neat cement into the surface well, pressing it and working it with a flat trowel. Onto this add a layer of strong mixture cement into which the tiles are pressed.

TO FINISH A TILE FLOOR the spaces between the tiles are filled with cement; a small narrow cement trowel or strip of metal is

passed over the strip to smooth the cement in between the tiles. After the first day the tiles and entire surface should be sprinkled with water to insure good hardening of the cement.

THE SPACES BETWEEN THE TILES can vary in width, depending upon the size of the tiles. A half-inch space of cement between six-inch tiles is a good average. A tile surface either upright or flat looks better with a liberal space between the tiles than where too close a connection is attempted. The tiles also look more interesting if the cement in between is left a little lower than the surface of the tile.

A color may be added to the cement used between the tiles, creating a pleasing contrast in color and values. This color may be a thin coating of color cement and need not be used throughout the entire cement section.

TO SECURE A LEVEL TILE FLOOR with the color cement tiles, the under layer of cement into which the tiles are placed should not be a wet mixture of cement but a mixture of cement and sand that is a little more moist than wet sand. The tiles are then pressed onto this layer, more of the moist cement being pressed under the tiles until the tiles are level with each other. To test the level surface a straight edged board is placed straight edge downward along the surface. If it rocks on any part of the surface, that part should be pressed downward or lowered by the removal of some of the cement. If parts are too low, they will show a light opening underneath the leveling edge and should be built up.

After the tiles are all level, the spaces between are filled with a soft mixture of cement and finished smooth.

TILES FOR INSERTS IN WALL PANELS can be made in the same way as described in the chapter on Tiles, excepting that they may be made thinner to conform with the thickness of the wood or other surface to which they will be added.

Where the wood or wall surface is grayed or toned with a paint wash or tint, the tint can be carried over the tile insert which will help the unity of the tile with the wall.

COLOR CEMENT TILES FOR FURNITURE INSERTS can be made in colors to harmonize with the wood background. The surface finish given the wood, whether wax or gray tone, can be also applied to the tile. The tiles may be applied to boxes, chairbacks, flower stands so that they become the bright spot of color motif to a design produced by the pattern of the wood, or a carved or relief enrichment on the surface.

UNIT TILES FOR WALL SURFACES can be made and planned so that various arrangements can be made by using the same motifs or elements. These elements can be combined into a group that may be inserted into an over mantel or into a wall or corridor space. Unit tiles admit of arranging a vertical or a horizontal border or of combining both borders each produced with the same motifs.

COLOR TILE BORDERS for plain cement floors will make an otherwise plain floor a thing of beauty. A series of tiles for the border can be made and special tiles for the corner arranged. The whole series can then be set at the same time that the center plain gray or tinted portion of cement is spread.

CEMENT FLOOR ABRASION CAN BE AVOIDED by dampening the cement as it hardens and spraying water onto it regularly once or twice a day after the first day for a period of five to seven days.

Abrasion or powdering of cement floors indoors often occurs because of prematurely drying when constructed. Where walks out-of-doors are benefited by the dew or moisture at night, inside floors do not receive this moisture and often dry too rapidly.

To remedy the abrasion, or powdering of cement floors, wash the floor thoroughly with clean water removing all dirt and particles with

a stiff scrub brush. After the surface has dried, apply a solution of one part water-glass (sodium silicate) of 40 degrees Baume and three to five parts water, the water depending upon the absorbing quality of the cement. This mixture is applied with a large brush and should be mixed well and used within an hour. When this has dried mop the surface with clean water and repeat the wash of water-glass three times, letting the floor dry after each operation.

The silicate penetrates the pores, comes in contact with the other alkalies in the concrete, forming an insoluble and very hard material, preventing dusting and makes a better wearing floor.

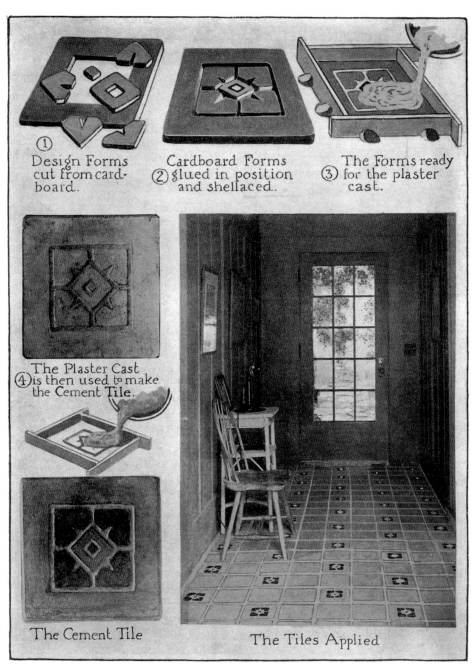

① Design Forms
cut from card-
board.

② Cardboard Forms
glued in position
and shellaced.

③ The Forms ready
for the plaster
cast.

④ The Plaster Cast
is then used to make
the Cement Tile.

The Cement Tile

The Tiles Applied

Color Cement Tiles for Interior Decoration

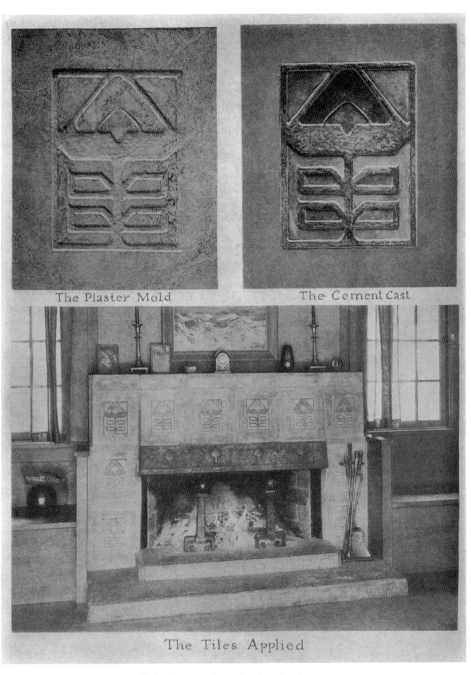

The Plaster Mold The Cement Cast

The Tiles Applied

Color Cement Tiles for the Fireplace

Tile Patterns for Wall or Floor

One hundred and fifty-six

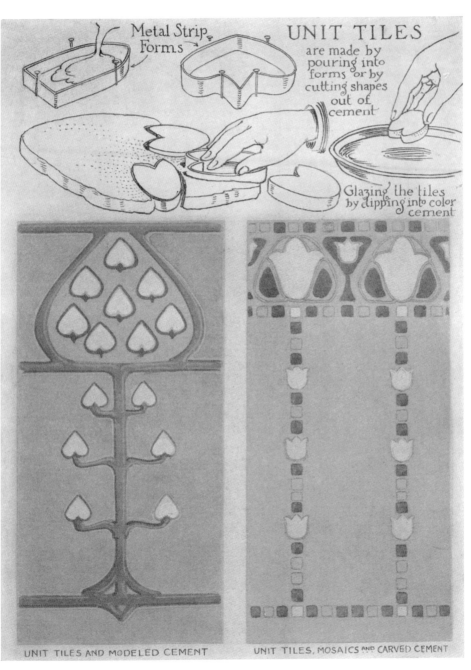

Metal Strip Forms

UNIT TILES are made by pouring into forms or by cutting shapes out of cement

Glazing the tiles by dipping into color cement

UNIT TILES AND MODELED CEMENT

UNIT TILES, MOSAICS AND CARVED CEMENT

The Unit Tile and Application

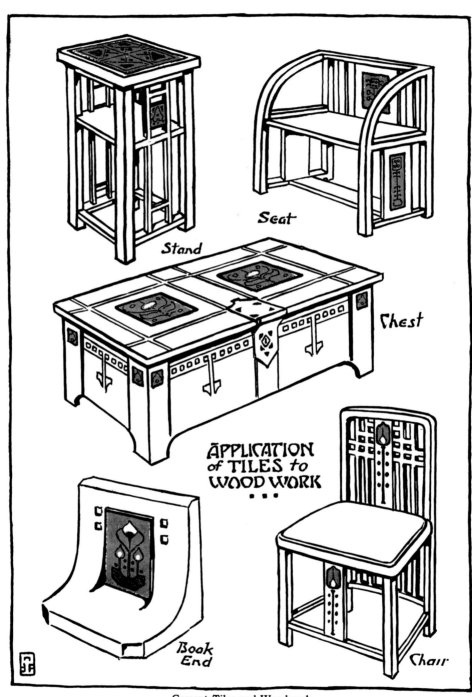

Stand

Seat

Chest

APPLICATION
of TILES to
WOODWORK
• • •

Book
End

Chair

Cement Tiles and Woodwork

CHAPTER 16

Surface Finishes

COLOR CEMENT TILES ARE SURFACE FINISHED generally after they are dry. As the tiles or pottery dry a lime or white powder dries on the surface and the colors appear to become dull. To bring out the colors and remove this powder, a soft cloth or soft brush is used to brush or dust off the tile surface thoroughly.

AN OIL RUB can be given to the surface of the tile with raw linseed oil on a soft cloth, and a brisk rubbing of the cloth will give a soft dull polish. This should be done only on the cast and dull finish tiles and not on the slip-painted or glazed surfaces.

A THIN SHELLAC COATING may be given a color cement tile or pottery as a preliminary to a wax polish or a gasoline wash. White cement tiles or pottery are very porous and a thin coating of clear white shellac will prevent over absorption of surface coloring if the shellac is permitted to dry thoroughly. Shellac should be applied after the surface is thoroughly dried to prevent a sticky surface.

THE GASOLINE WASH is made by mixing white oil paint (flake white or zinc white) with black paint (ivory black or lamp black) until a gray tone is secured. This mixture should be made in a cup or bowl so that gasoline can then be added until the paint is almost as thin as water. To this mixture green or blue paint or other color should be added until the right hue is secured. This is then brushed onto the tile surface and brushed well into the crevices and countersunk sections as it is important that the low sections be well filled. After the wash has dried thoroughly, a soft cloth is used to rub off all the surplus. This will leave the gasoline wash remaining only in the bottom or lower portions giving a pleasing finish. After this has dried a wax rub may be placed over it.

A WAX RUB is produced by taking either wax tan shoe polish or floor wax and rubbing it onto the cement with a soft cloth. The cement should be thoroughly dry before the wax is placed upon the

surface. After a few minutes a soft brush or woolen cloth should be used to polish the waxed surface.

A wax rub can be applied over a gasoline wash, but only after the wash has been given time to thoroughly dry. If the gasoline wash is not dry, the wax will remove it in parts and destroy the effect produced by the gasoline wash.

A COLOR CEMENT SURFACE FINISH is made by mixing a thin mixture of color and cement which is then brushed onto the tile. The tile or surface to be finished with cement should not be dry or be permitted to dry after it has been removed from the mold. Previous to the application of the cement color, the tile should be well moistened. After the color has dried for several hours upon the surface, a cloth balled or gathered so as to form a padded surface should be used to remove the color from the high parts.

A SLIP SURFACE FINISH is where the tile or surface has been completed in single or several colors and when hardened sufficiently in water, a thin slip of color cement is placed over the entire surface and permitted to settle into the hollows, leaving the higher portions to appear more clearly through the colored slip. If the surface is a tile, it should then be permitted to harden in shallow water placed in a tray with the tile placed carefully into it so that the water does not reach the color slip portions. If the object is a vase, it may be filled with water to harden the outer surface properly. If the color has been used as a layer on the inside, the bowl or vase should be placed in a pail and water poured into the pail so that the object is surrounded with water. A weight or board can be placed so as to prevent the object from floating if it commences to do so.

COLOR MAY BE SPRAYED by mixing a thin mixture of color and cement and spraying it onto the tile or pottery surface with a fixitive blower such as may be obtained at artists' supply stores and

which is used by artists for spraying a solution of shellac (termed fixitive) onto charcoal or pencil drawings.

The color should be repeatedly stirred to keep it well mixed and if the sprayer becomes clogged, it should be rinsed in water.

Too much color should not be sprayed at a time as it will fail to be absorbed and run on the surface, resulting in streaks.

SPATTERED COLOR FOR SURFACES is secured by dipping a short-haired bristle brush (the bristles are best when they are about one inch long) into color cement and causing the color to spatter onto the surface by rubbing a knife edge or straight edge of a stick along the brush. This will cause the bristles to release suddenly, throwing pigment in the opposite direction onto the object. A trial should first be made on paper surface before the actual surface is used to avoid too much color, such as would come from an overcharged brush or too vigorous rubbing. The surface of the object should be moist or dampened well previous to the spattering.

SPRINKLED DRY COLOR can be applied to surfaces. This will give a pleasing effect in certain places where an antique or scattering of dry color will enter into the nature of the design. The dry pigment can be sprinkled onto the surface only where the surface has been covered with a layer of other color that is still moist. This is necessary in order that the dry color will absorb sufficient moisture from the other color to amalgamate with the first color.

TEXTURE SURFACES are produced by working on the surfaces while they are still moist or soft enough to admit the use of a tool or edge to press or model the surface. Even when a surface might have become quite hard it may be tooled or chipped and a cement wash or gasoline wash used to give the tooled parts a unifying color.

REPEATED SURFACE COLORING may be done where the first coloring is not satisfactory. It will be found that a more pleasing

effect is often produced by the second surface coloring being placed over the first. Care should be taken that so much rubbing does not occur that it wears parts of the tile or pottery surface that are soft.

SURFACE FINISHES PERMIT OF EXPERIMENTING and the craftsworker in color cement must test out different combinations in order to achieve the most desirable quality to respond to personal choice. A brilliant color wash will often bring out the pattern in pleasing contrast, and at other times it may be over absorbed and produce a mottled undesirable quality. The condition of the molds and the amount of sand in the mixture all influence the surface of the object and in turn influence the result of the surface finishes.

GASOLINE WASH FINISH

FIRST· A little white and black oil paint

SECOND· Add green or some other color

THIRD· Add gasoline to the paint until it is a thick liquid.

FOURTH Brush the gasoline wash over and into the color cement surface

FIFTH After the gasoline wash is dry it is cleaned off with a soft cloth

SIXTH Floor wax is rubbed onto the surface

SEVENTH The surface is then polished with a brush to finish it.

A Surface Finish for Cement Handicraft

CHAPTER 17
Decorations in the
Open

COLOR AS OUTER ARCHITECTURAL DECORATION was much used on the buildings of Egypt and Assyria. The winged sphere in gold and amber against a background of dark blue was commonly used on the outer walls of Egyptian buildings and the processions of warriors and ancient kings decorated the walls of the Assyrian cities.

THE GRECIANS USED COLOR ALSO and the beautiful Parthenon was decorated with color and the restored model in the Metropolitan Museum of Art in New York shows their use of color architecturally. The great Acropolis was resplendent in bas-reliefs on the outer walls in color, gold and silver.

THE ROMANS USED COLOR OUT OF DOORS on their buildings and the Etruscans built in terra cotta coloring the outer walls with gorgeous decorations. They recognized that architecture could be dignified and noble with proper use of color decorations to enrich the building as a whole.

MURAL DECORATIONS IN THE OPEN were used by the Egyptians, examples of which remain in our museums today, and so permanent were their colors that the color schemes are apparent even at this day thousands of years after their artists applied them.

Pompeians with their house-tops massed against their blue skies were prompted to use orange-red largely in their decorations which were lavishly applied in their gardens and other surroundings.

THE CHINESE USED COLORS SIMILAR TO THE POMPEIANS and their decorations give brilliant notes to their buildings creating pleasing effects. The Chinese medium has been one largely of lacquer which has been used over their gold and painted color, producing transparent qualities making it difficult to know where the actual surface begins.

COLOR ON OUTSIDE BUILDING SURFACES exists on many of the Italian cathedrals and enriched color facades were used on many houses during the Gothic period of which there remains examples at Heldesheim and Nurenberg and other cities.

COLOR IN AMERICAN ARCHITECTURE IS POSSIBLE with the use of color cement and with careful analysis of the colors used and methods of hardening, the patient worker can accomplish much toward realizing this much sought possibility.

THE FIRST STEP TOWARD SUCCESSFUL USE OF COLOR CEMENT in the open is to realize that color used at all times must be protected from drying too rapidly. If it does so, it will disintegrate and chalk away gradually. The drying of color cement should be retarded as much as possible and kept moist as long as the hardening process has not completed. It is impossible, of course, to apply water to the face of a working surface without destroying the glaze of the color, or the surface setting layer once the surface commences to dry. Water applied at this time will cause the surface to float in sections and ruin the entire surface. Therefore the best way is to arrange for the water to be absorbed from the back and this can be done easily where the panel or mural decoration is a separate section to be applied to the building surface afterwards.

WHERE THE MURAL IS TO BE APPLIED TO THE WALL the surface must be first roughened, next thoroughly dampened with water, then a layer of wet neat cement placed upon it. The bed of cement or sand and cement is next applied and the subject then applied onto this surface all at one sitting. This is necessary to avoid any part drying, as it will be impossible to dampen the surface for postponed work.

BETTER RESULT ON WALL DECORATION is possible where the color cement can be applied before the wall mass has dried

out.　If the forms or board walls can be removed before the cement has thoroughly set, whatever color cement or cement underlayers necessary to the color surfacing are placed upon it, will stand greater chances of remaining as a permanent part of the whole structure.

TO PROCEED WITH A MURAL PANEL a pan of metal two inches larger each way than the panel dimensions should be made from galvanized sheet metal.　This is to hold the mural cement slab onto which the subject is to be painted.

THE CEMENT SLAB IS MADE by surrounding an oiled surface (wood or glass) with wooden retaining walls similar to those used in making tiles.　These walls should be oiled and otherwise made proof against leakage of water as it is necessary that all water in the cement be retained to perfect the hardening.　The mixture of sand and cement (one part cement and two parts sand or gravel) is next poured into this space and permitted to set for several hours.　Over this surface a thin layer of neat cement may be spread or dry neat cement sprinkled through a sieve and worked into the moist surface with the flat side of a palette or other knife.

THE COLOR IS THEN APPLIED by mixing up the colors to be used into a paste form and these can be applied with a brush or with a palette knife shaping and forming the subject as if painting in ordinary colors.

If the color sinks in too rapidly and becomes lost, the under surface is too wet and the painting should be delayed for several hours or until the color applied lays upon the surface properly.

THE CEMENT SLAB IS TRANSFERRED TO THE METAL TRAY as soon as it is removable from its surface.　In fact, a good way is to move the wood or glass under support with the cement slab upon it and place the whole combination into the tray.　If the sides are well set the retaining walls can be removed, and as soon as the

whole layer is set enough so as not to be dissolved by water, water is poured in the tray until it comes half-way up the side of the cement slab. This will prevent the whole slab drying prematurely as the water will supply all that is needed. If the water becomes absorbed more should be poured in. After it has remained in the tray for a week, it may be withdrawn and permitted to dry gradually. Wet cloths around it will prevent too rapid drying.

WHEN WORKING UPON THE SURFACE, the surface should be completed as the space is covered, avoiding returning to work upon any part after it has commenced to set. If the surface has formed a shell or thin layer and reworking breaks this shell, the color in that section will not harden properly. It requires direct, confident handling of the subject, and reworking of the surface such as the painter in oils is accustomed to is not possible with color cement.

A WHITE CEMENT SURFACE can be formed over a cement layer and when this is nearly dry thin washes of color cement may be used onto the surface similar to working with water color. The white cement will absorb the color easily and parts of the design may be worked in opaque or solid colors.

A DARK WORKING BACKGROUND may be used by mixing a layer of dark blue, brown or green. A layer of black can also be used. Brilliant colors can be brushed or dripped into this so that they sink and become a part of the dark surface without being in relief. A slight shaking of the surface or the tray will produce this amalgamation of colors.

WATER SHOULD NOT REACH THE COLOR SURFACE until after it is entirely dry. To avoid water splashing onto the surface from the tray it is the best policy not to pour water into the tray before the painting is completed and only when the tray is to be left undisturbed.

TO CONNECT THE COLOR CEMENT MURAL with the building wall, the space to receive it should be well moistened and covered with neat cement which is well worked into the surface. The back of the cement mural is similarly treated and the two cement surfaces are pressed together and held in position by a brace or support until thoroughly dried. The space or border edge around the panel should be filled in with cement at the same time.

Decorations Painted with Color Cement

One hundred and seventy-one

Cement Color Painted Decorations Applied

One hundred and seventy-two

CHAPTER 18

Tiles and Pottery
with Color Magnesite
Cement Work

MAGNESITE CEMENT WORK is a mixture medium producing a hard marble-like quality and does not contain any Portland cement, but is given in this book in order to complete the possible plastic mediums for the worker wishing to mold objects with permanent durable mediums.

MAGNESITE CEMENT IS A SUCCESSFUL INDUSTRIAL MATERIAL and is used by builders in interior trimmings for floor tiles, in making of bath-room surfaces and recently used in coating stairways and hallways, producing a pleasing texture and durable surface. The material is fireproof, cleanly and better than marble.

MAGNESITE IS A FORM OF LIMESTONE and is a carbonate of magnesia which is produced by burning until all gases have been eliminated, leaving only the oxide in the form of a pure white powder. It comes from Europe and is found in Maryland, Massachusetts, New York, Vermont, California, and Washington. It has been used extensively in Europe and when better known will be used more generally in America.

MAGNESITE CEMENT AS AN ENAMEL has been used as a hardening surface on concrete and cement surfaces and also on clay brick. The concrete or cement or brick surfaces should be thoroughly moistened before the magnesite mixture is placed upon it to avoid the moisture from the magnesite being absorbed and improperly drying.

THE MATERIALS FOR PRODUCING MAGNESITE are calcined powdered magnesite, chloride of magnesia, sulphate of magnesia, white sand, white talc and fine sawdust.

The magnesite should be kept in a container, proof against exposure to air and dampness, in order to preserve its full setting qualities.

Chloride of magnesia has the appearance of ice or alum and when exposed has the tendency to dissolve but does not deteriorate. It is

the chemical which when united with the magnesite produces the binding or cement qualities.

Sulphate of magnesia or epsom salts is an easily secured material and is used in very small quantities in the formulae for producing magnesite cement and which is given later in this chapter.

The white talc or soapstone used for giving a smooth and polished white background is used as a filler.

White sand and the fine sawdust should be absolutely clean and are mixed with the other ingredients to produce the composite mixture to produce Magnesite Cement.

TO COMBINE THE INGREDIENTS proceed as follows:

FIRST MIXTURE. Two and one-half pounds of powdered magnesite and one pound of white talc are mixed thoroughly with one quart of fine sawdust. To this mineral, dry color similar to that used and described for color cement should be added if a color tone is desired. About one-half as much color should be used as there is magnesite. In other words, one pound of color should be used with two and a half pounds of powdered magnesite. A stone mortar should be used to grind the entire mixture well together.

This first combination is a dry mixture and is then mixed with the second mixture which is liquid.

SECOND MIXTURE. Take five parts by weight of chloride of magnesia solution with a density of 25 tested with a Beaume hydrometer which is a simple glass tube secured at any druggist for registering solutions. To the chloride of magnesia solution add one-half part by weight of sulphate of magnesia which is epsom salts and test with the hydrometer until it records 15.

TO USE THE HYDROMETER, place water in a container and if the hydrometer is placed in it, it will register "0" and when the chloride is placed in it, and dissolves the hydrometer will commence

registering the density of the solution. When it records 25 no more chemical should be added. More water should be added to correct the density if needed. The same procedure is followed for registering the 15 for the epsom salts.

Chloride of magnesia will dissolve more rapidly if it is broken up, and distilled water may be used if the usual available water contains lime, iron or other injurious minerals. Some workers use rain water for many purposes.

THE FINAL MIXTURE, or third step in the mixing, is to take the first dry mixture and add enough of the second liquid combination to produce a thick creamy mixture of the two. Strain this after it has been well mixed.

TO PRODUCE TILES OR OTHER OBJECTS, THE MATERIAL is quickly poured into the molds. A brush may be used for brushing the material well into the edges and corners. A gentle jarring of the mold will remove the air bubbles and the molds with the magnesite is permitted to dry for seven to ten hours before the cast is removed from the mold.

FOR VARIOUS COLORS in the same design, the dry mixture can be mixed with color and the liquid, or second mixture, added to it. This can be applied to the mold in the same way as the color was used with cement, and after it has set, can be backed with a general color of magnesite cement or with plain magnesite mixture.

TO FINISH MAGNESITE let it remain drying for two or three days after which it can be washed with slightly warmed water to remove the thin scum on the surface. A thin coating of beeswax or floor wax well polished will finish the article.

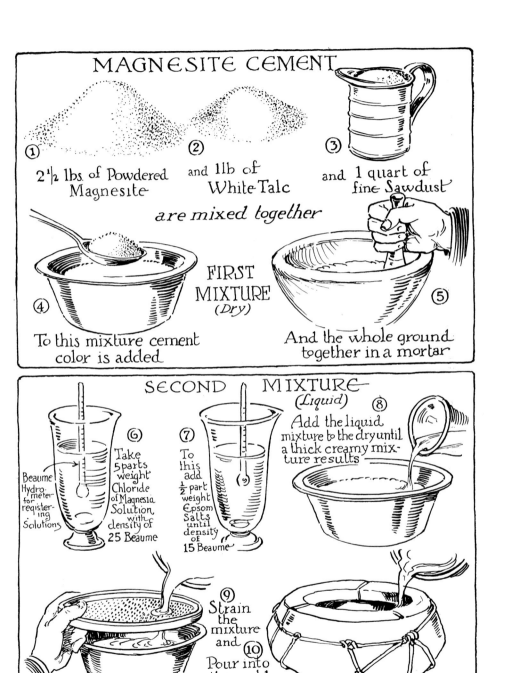

MAGNESITE CEMENT

① 2 1/2 lbs. of Powdered Magnesite

② and 1 lb of White Talc

③ and 1 quart of fine Sawdust

are mixed together

FIRST MIXTURE *(Dry)*

④ To this mixture cement color is added

⑤ And the whole ground together in a mortar

SECOND MIXTURE *(Liquid)*

⑥ Beaume Hydrometer for registering Solutions — Take 5 parts weight Chloride of Magnesia Solution, with density of 25 Beaume

⑦ To this add 1/2 part weight Epsom Salts until density of 15 Beaume

⑧ Add the liquid mixture to the dry until a thick creamy mixture results

⑨ Strain the mixture and ⑩ Pour into the mold

The Making of Magnesite Cement

One hundred and seventy-seven

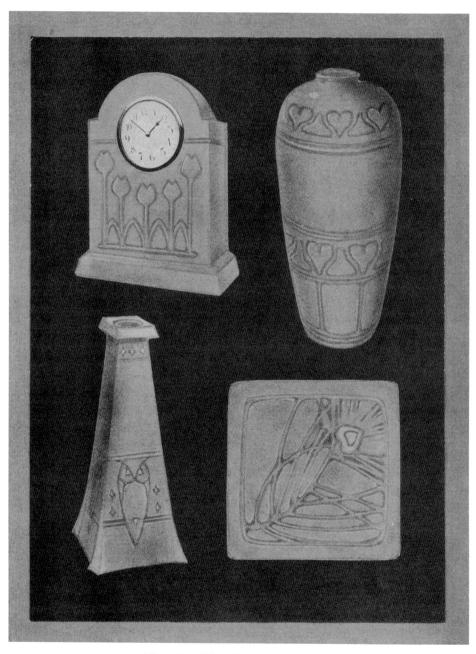

Magnesite Objects Cast from Molds

CHAPTER 19
Color Cement
Projects
for the Schoolroom

CEMENT TILES simple in form may be made in any grade where tiles are made in clay or the modeling waxes. Many times clay is used in making tiles and the coloring is done with colored chalks or paints. These can be but temporary in effect and are broken easily, being impractical for use. The child's interest will be much greater where he knows that with cement the results will be durable as well as to know that he is working with the same materials that the "grown-ups" use.

COMMENCING WITH SMALL TILES IS THE BEST PLAN. Have the class plan from nature a rosette design for a two-inch tile. An excellent way to secure interesting patterns is to fold a two-inch square paper into four folds and cut a design in the four folds. Opening out these folds will often reveal a very interesting design. When the student has completed the design, it can be traced with a pencil onto a flat layer of modeling wax, and a pencil, stick or nail used to cut away portions of the design. The pattern designed may be the part taken out or the background may be the part to be removed. In either case the part removed should be scraped out about a quarter of an inch deep and the sides should not slope in but rather outward. If the design is to be simply produced by incised lines only (and charming results can be thus secured), the stick, nail or instrument used should be sharpened so that it scrapes a groove in the clay that remains widest at the surface. The design being completed in the clay or wax, a few strips of thick cardboard or heavy oiled paper is cut so as to project above the clay or wax tile. This projection must equal the thickness of the mold to be made in plaster-of-Paris. These strips may then be placed up against the tile so as to surround it, and are to be retained in position with nails or pins or heavy objects.

When the pupils have all reached this stage of the tile, the teacher then may mix up the plaster and pour it into the molds, illustrating the correct method for the students to afterwards follow.

AFTER THE PLASTER TILE IS RELEASED, it is brushed well with oil and again surrounded with the strips of paper. Cement with any desired color added to it is then poured in and after two or three days the completed tile can be removed.

To secure color effects it is only necessary for the teacher to mix two colors of cement sufficient for the student's use. The student then places a thin layer of the color on the plaster mold, keeping it within a certain portion of the design. The second color is placed on the spaces left, and after the color has set for a short time it is backed with ordinary neat cement and the whole tile permitted to dry several days.

TILES WITH THE DESIGN IN A RELIEF LINE can be made as follows: The teacher should have previously made a number of plaster tiles with a smooth surface. These can be easily made by flowing the plaster onto glass or other hard, smooth surface, the plaster being retained between two strips of wood 4 x 4 inches. Cutting these bars of plaster into squares, one is given to each student. A simple design is made on paper first and traced onto the plaster tile. A nail or hard pencil is then used to incise the design in the plaster, after which it is brushed well with oil and surrounded with cardboard strips and cement poured into it. This will result in a tile with the design in relief. Within these relief lines cement with color added to it may be placed and the tiles placed in a tray of water with the water coming half-way up the side of the tile. The tile will be hard enough to remove in five days.

SIMPLE ROUND PAPER WEIGHTS and tiles that are not square can be made by the same method. A little ingenuity in arranging the retaining cardboard strips around the plaster or wax model will solve the producing of irregular forms.

FLOWER AND PLANT HOLDERS, FISH PONDS, AND BOOK SUPPORTS can be made by using the tiles as the principle

part. Take four tiles that have not been permitted to dry and place them face against the inside wall of a rough box form without the bottom, the size of the box to conform to the tiles. Pour about an inch of cement into the bottom of the box to form a bottom. When this has partly set, place strips of wood across the inside covers to hold the cement which is then poured in so as to connect the tiles where the corners meet. The cement should be poured also into the outside corner spaces. After the complete form has dried for a day, pour water inside and let it remain for three days or more. Release and trim corners and inside as desired. A thin mixture of colored cement placed inside and then poured out will give an inside lining, producing a finished effect.

SAND BOX ANIMALS AND TOYS can be made in a very durable form by the use of cement. The method to follow in class should be as follows: Have the pupils outline an animal in simple form on paper. No intricate or small details should be attempted in this outline and the feet or lower portions of the animal must be planned so that it will stand up easily.

After the outline is made then secure thin strips of tin or other sheet metal and have the pupils bend it with their fingers and with the use of a ruler to conform to the outline. The metal should be about two inches wide. The outline need not be made entirely of one piece of metal but perhaps of several. When the outline is completed in metal, it should conform fairly closely to the outline on the paper. This metal rim is then pressed slightly into wax or clay, or it may be placed on glass or on an oiled card. If clay is used, the eyes, wings, or other parts may be incised in the clay within the metal rim. A one-inch layer of cement is then poured in the metal rim, and after several days, the metal rim is removed and the cement around it is evened where necessary and colored if desired. By making the feet of birds or animals first, combining wire legs with them, the body can

then be cast, combining the body and the legs through the wire connection.

MOSAIC CEMENT TILES can be easily produced as follows: Secure a number of the small mosaic stone squares used by masons and tile setters for inlaying floors. These come in many colors and different geometric forms. Plan a four-inch tea tile arranging a design with the use of two or three different colors of mosaics. When the arrangement or design is decided upon, the mosaics should be glued face downward to a piece of cardboard or glass. If glass is used, it should be brushed with oil after the mosaics have been glued into position and before the cement is poured. Where glass is used the design arrangement on paper can be slipped underneath the glass to show the location and correct position for gluing the mosaics onto the glass surface. The mosaic pattern is then surrounded with retaining bars or slips of wood or surrounded with metal and the cement poured over the mosaics until the right thickness is secured. It is then left for several days to dry, after which it is removed from the glass or the cardboard is peeled away from the cement surface. The tile is then finished after being placed in water for a week to harden. Glue a piece of soft leather or felt on the bottom when the cement has thoroughly dried.

CEMENT BOXES AND BOOK SUPPORTS can be made by the use of mosaics, gluing them onto sections of boards and then assembling the boards and tying them so that they will hold the cement that is poured in to finish the object. Where cement is removed from the mold before it has thoroughly hardened, it can be shaped with a knife, and mosaic book supports or boxes made in general form can be shaped easily this way.

VASES AND BOWLS as a problem for the schoolroom can be simplified if the teacher produces previously several vase molds so

that the pupils can make their casts in individually selected colors, after which they can scrape or slip paint the shapes as they are removed from the molds.

THE POSSIBILITIES OF COLOR CEMENT for schoolroom applied arts are many and the interested teacher can arrange working equipment and methods of presentation according to space and class size. One ingenious teacher placed building paper on the floor of a schoolroom corner section, covered several old tables with oil-cloth and secured excellent results with her class room problems by permitting a small group of students to work at a time on account of the limited equipment.

Another teacher had her students design and make tiles for a new school building and today they are used as part of the enrichment of the school. This correlation of the student's work with every day utility is one of the attractions of color cement for the school student, and innumerable practical applications can be found for color cement. The various problems for which directions have been given in the chapters of this book can be arranged in more or less simple form for the various school classes; and as a vocational subject it combines design with construction in a sensible proportion.

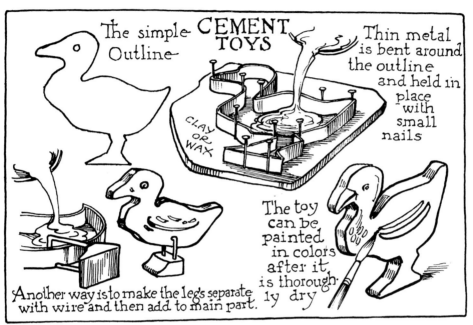

The simple CEMENT TOYS Outline

Thin metal is bent around the outline and held in place with small nails

CLAY OR WAX

The toy can be painted in colors after it is thoroughly dry

Another way is to make the legs separate with wire and then add to main part.

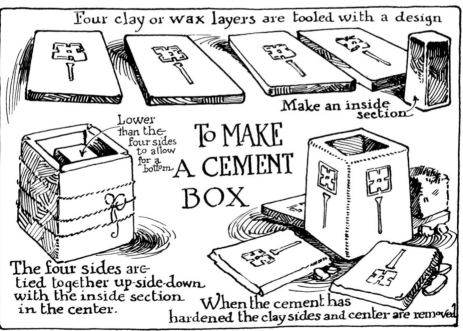

Four clay or wax layers are tooled with a design

Make an inside section

TO MAKE A CEMENT BOX

Lower than the four sides to allow for a bottom

The four sides are tied together up-side-down with the inside section in the center.

When the cement has hardened the clay sides and center are removed

Schoolroom Projects in Cement

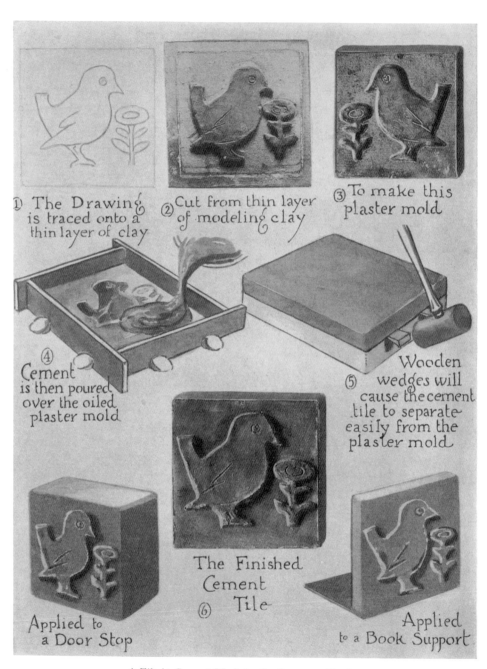

① The Drawing is traced onto a thin layer of clay

② Cut from thin layer of modeling clay

③ To make this plaster mold

④ Cement is then poured over the oiled plaster mold

⑤ Wooden wedges will cause the cement tile to separate easily from the plaster mold

⑥ The Finished Cement Tile

Applied to a Door Stop

Applied to a Book Support

A Tile in Cement Made in the Grammar Grades

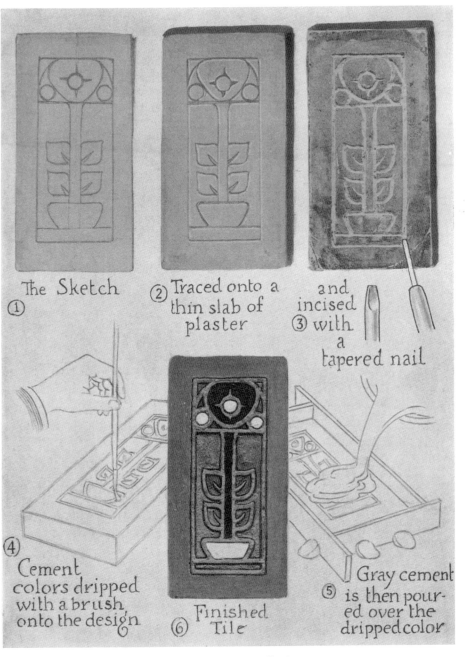

The Sketch ① Traced onto a ② thin slab of plaster

and incised ③ with a tapered nail

④ Cement colors dripped with a brush onto the design

⑥ Finished Tile

⑤ Gray cement is then poured over the dripped color

A Tile Made in the Intermediate Grades

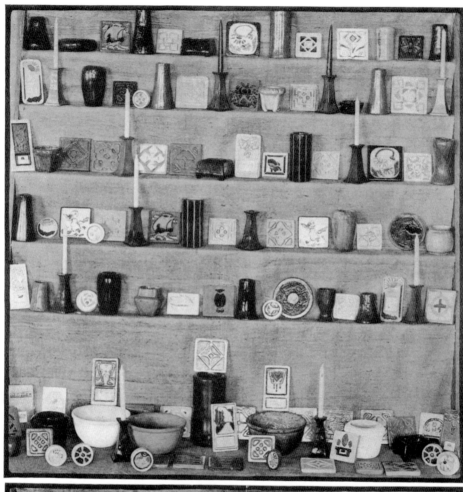

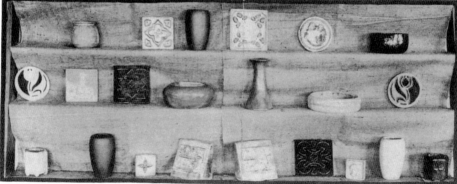

Color Cement Tiles and Pottery Made by the Students of a High School.

One hundred and eighty-eight

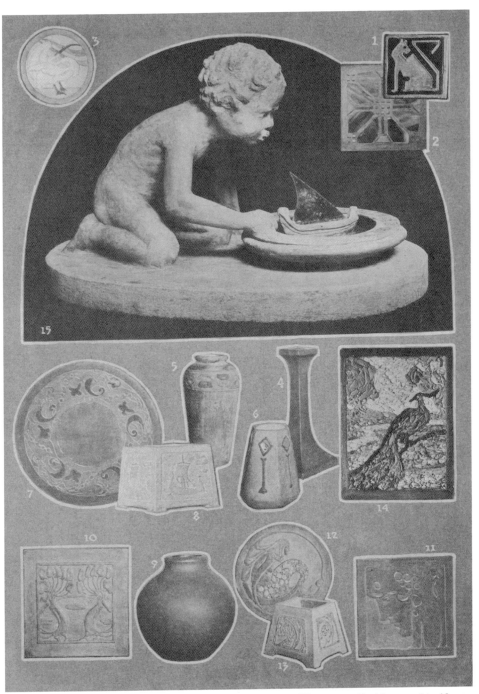

Problems in Cement by Students of an Art School. 1 to 3 are Elementary Problems. 4 to 13 are
Secondary Problems. 14 is a Palette Knife Painting in Colored Cement. 15 is a Fish Bowl and
Sun-Dial Made in Cement by the Use of a Glue Mold.

CHAPTER 20

Designing for Tiles
and Pottery

PRINCIPLES OF PATTERN DESIGN are important for the craftsman to be familiar with, for the reason that it gives points with which to "check up" drawings before they are applied, as well as to permit greater facility in designing.

MANY DESIGN WELL without having learned the theories of design, having a natural sense of good arrangement of details and spaces. However, natural designers, as well as those who do not find it easy, will profit by becoming well grounded in the design principles.

NATURAL FORMS afford excellent examples of principles, giving beauty in line, form and color; and the more the designer refers to nature for these ever occurring lines of grace and beauty, the greater will be his development as a designer.

SUCH STUDY FROM NATURE should be intelligently pursued. To study nature for design motifs does not mean that "photographic" arrangement or life-like sprays should be applied onto surfaces. The most deplorable forms applied to pottery or other handicrafts are those that have been made with no thought of the surface influence upon the pattern designed. The designer should refer to nature only as a reference from which inspiration is received for motifs to be used. In every instance the forms in nature should be interpreted into design and so transposed that they beautify the surface irrespective to resemblance to the natural source. Nature uses patterns in all her kingdoms correctly. The patterns on petals and leaves, the pattern on bird plumage and animal skins, as well as nature's designs on minerals are all beautifully arranged to conform to the contours of the surface. It would have been just as easy for the Great Creator to produce forget-me-nots and violets in natural splendor upon the leopard, but the ringed spots varying and converging to the lithe, graceful lines of the surface without any appearance of being in relief upon the skin are much more beautiful. Those who state that "Nature cannot be improved upon" as an excuse for

natural representation in designing are overlooking nature's real poetic opportunities to the designer. No true artist or designer ever hopes to actually represent nature. It is impossible. The best that can be done is each individual artist's interpretation of nature forms founded upon governing principles. These principles have been tested by centuries of scrutiny and all beautiful forms of historic ornament are governed by principles which, as has been stated, originated in nature's design forms.

RADIATION, SYMMETRY, UNITY, SUBORDINATION, MEASURE, ETC., are all principles of importance, but the three that are of great value to the craftsman are Measure, Balance and Unity.

THESE THREE PRINCIPLES can be used to test the line, form and color of the design before it is applied.

MEASURE is the principle that requires a consistent varying of areas, line directions or colors. Measure creates interest. It does not mean that large and small parts are to be designed without any further consideration. There must be a right proportion of one to the other and balanced as regards their location. Measure will control the contours or forms of vases and motifs for if the widest part of the form comes above or below center of the axis, it will be more interesting than if located in the center. The working plate illustrates this.

BALANCE is the principle which creates harmony by contrasting measures. If we have a heavy spot on one side of a design, the eye requires satisfaction by seeing another spot or several parts equal in weight to the large spot on the opposite side of the design. Balance is also secured by locating a unit or design spot in the proper location of a space, without necessarily having a second opposite spot. Nevertheless, it is balance in relation to its background. Balance may

be secured by Symmetry, making parts like-sided or balance may be secured by equal amounts of form on two sides of an axis, even though not symmetrically placed. (See working plate.)

Balance in color requires that if a color is used in a single spot that its location be pleasingly balanced within the space decorated. Where a color is to be used in several places in the design, these different spots should balance each other.

UNITY is the principle which brings harmony into design by similarity of parts, by keeping lines of a design parallel to the space outline within which they are designed. Again the main lines of a design if radiating from a point or axis within or without the design space produces unity. Unity is produced by harmonious values and by harmonious color.

A DESIGN WITHOUT UNITY may be one where the parts are too varied in form, where they do not pertain or group with each other, but appear "explosive." Different finishes to the motifs in a design destroy unity. Avoid mixing naturalistic or conventional and geometrical motifs in the same design, and using lines or forms which are not pleasing in direction, or harmonious with the space in which they are placed.

UNITY requires that all parts of a design be of similar expression. To have one part of a design based upon a poppy or bird with a section drawn naturalistic and another part conventionalized and possibly a third section in geometric arrangement is to produce disorder or dissimilarity, and yet such fault is apparent in a large proportion of designs.

ALL DESIGN FORMS CAN BE DIVIDED INTO FOUR DIVISIONS and these divisions can be defined as Naturalistic, Conventional, Geometric, and Abstract. If any design motif for a tile or any application is started in a Naturalistic manner, then all parts should be expressed in the same manner.

THE NATURALISTIC DIVISION OF DESIGN is where natural forms and growth arrangements are planned or designed within a given or arbitrary space. The decorative arrangement comes from carefully planning the subject so that it composes in a pleasing way within the space. The Japanese designs are good examples of this kind of decoration. It will be found that careful attention is given to the background spaces as well as to the parts of the subject being drawn. Strong outlines, double outlines and individual techniques or renderings further increase the decorative quality of a naturalistic design.

THE CONVENTIONAL DIVISION OF DESIGN is where a typical form from a nature growth is taken and repeated in regular repetition, or a general shape formed from a plant form and used to interpret the subject. For instance, a flower with several petals will have each petal different in contour, but in conventional design, one shape is chosen and this shape is repeated. While no two leaves are alike on the plant, one or two conventionalized shapes are determined and these shapes are then used throughout the design. The veins and stems of the flowers may be elaborated or the leaves may have their centers designed or "inhabited" so that added interest may be created in the subject.

THE GEOMETRICAL DIVISION OF DESIGN is when the subject is designed entirely with triangular, rectangular, square, oval, elliptical, or circular shapes, or where the outlines follow straight lines which may go at right angles to each other or in oblique directions. Such straight line designs are technically required for rug or textile designs and due to the ruggedness and strength or interest achieved through a straight line rendering are often adapted for decorating many other forms of applied art.

THE ABSTRACT DIVISION OF DESIGN is represented by that form of design which may have little direct representation of the

natural forms, but has been developed from it. We find that the wave border of the Egyptians and the Greek fret are abstract designs of the water. The Peruvian Inca, the Aztec and North American Indian used abstract designs of the bird and other nature forms in their textiles and pottery. The abstract design requires a careful arrangement of line and form spaces, depending as it does on good design for interest rather than its identity to nature forms.

LINE UNITY is that principle which appeals to the eye by the relation of lines in the design to the space decorated. Curved lines for curved forms and straight lines in the designs decorating straight lined forms will do much toward making all parts consistent. A line not too curved and with a blending of straight lines with the curved direction produces a line of character and strength for design rendering.

A TEST OF GOOD DESIGN is to see if the main lines or "frame lines" are pleasing in direction, decorating the space, whether any more details are added or not. No amount of filling in and adding of motifs will perfect an imperfect beginning.

BLOCKING IN of general forms is considered essential in freehand drawing and it cannot be discarded in designing. First plan the main lines of growth of the design. Then block in the masses or motifs to be used. The details and connections as well as the technique of the design will then be a simple matter to solve.

THE GREATEST ENJOYMENT to the craftsman in any line of endeavor lies only through working out of Good Design.

WHEN MODELING FOR COLOR CEMENT HANDICRAFT or for any applied art it will be found that three forms that are least modeled will be most pleasing in the years of usage. High relief is not refined or deservable in applied modeling. Sculptors everywhere are studying and returning to the chaste, quiet forms of

flat bas-reliefs of which we find excellent examples among the early work of the Egyptians, Byzantines, the early Indian and Chinese carvings, as well as the work of the Aztecs and Maya Indians of early America. A few examples of these types are shown and workers in color cement will find ultimately that they have chosen a good influence if they will work their projects in color cement handicraft in this manner.

High projecting parts and naturalistic representation of flower or foliage masses are neither pleasing nor artistic and a visit by anyone to the good museums will fail to find any such productions from the art ages of the past recorded as good examples of the era.

Keep all parts applied to the curved or flat surface of the bowl, vase, box or tile so that it appears to have been always a part of it rather than an afterthought and detachable in relation.

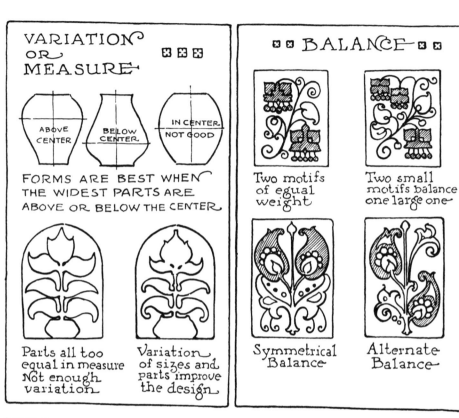

VARIATION OR MEASURE

ABOVE CENTER | BELOW CENTER | IN CENTER NOT GOOD

FORMS ARE BEST WHEN THE WIDEST PARTS ARE ABOVE OR BELOW THE CENTER

Parts all too equal in measure Not enough variation

Variation of sizes and parts improve the design

BALANCE

Two motifs of equal weight

Two small motifs balance one large one

Symmetrical Balance

Alternate Balance

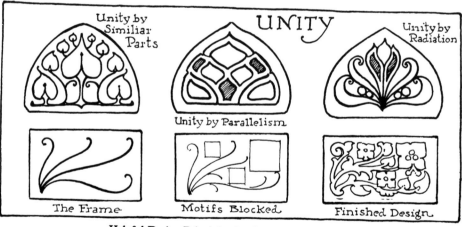

Unity by Similiar Parts

UNITY

Unity by Radiation

Unity by Parallelism

The Frame

Motifs Blocked

Finished Design

Helpful Design Principles for Color Cement Work

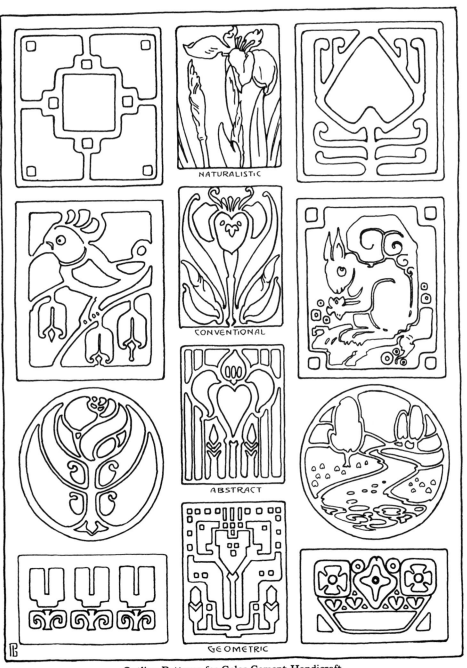

Outline Patterns for Color Cement Handicraft

One hundred and ninety-nine

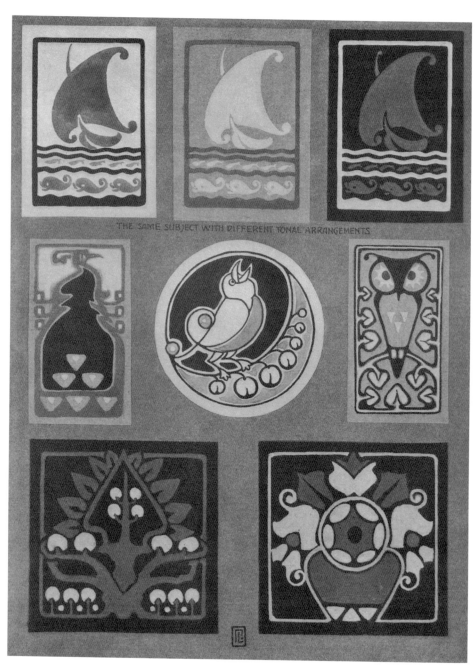

THE SAME SUBJECT WITH DIFFERENT TONAL ARRANGEMENTS

Tone Patterns for Color Cement Handicraft

Egyptian, Roman and Aztec Relief Decorations